IMAGES
of Aviation

LaGuardia Airport

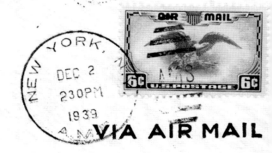

THE OPENING
N.Y. MUNICIPAL AIRPORT
LaGuardia Field,
L.I, N.Y, DEC. 2, 1939

NEW YORK, N.Y
DEC 2
230PM
1939
A.M.

VIA AIR MAIL

Mr.I.P.Sulley,
#210-29th Street,

North Bergen,N.J.,USA.

VIA AIR MAIL

OPENING OF NEW YORK MUNICIPAL AIRPORT. This cover already shows the airport having the additional name of LaGuardia Field. The cover is dated December 2, 1939, which is when the post office switched regular operations over to LaGuardia after the Newark Airport airmail contract expired. (Cradle of Aviation Museum.)

On the cover: **THE SKYWALK AT LAGUARDIA, C. 1948.** Like an aviation amusement park, a trip to the airport in the 1940s and 1950s was regarded as a fun day out for the family in New York. For the cost of a dime at LaGuardia Airport, one could watch the newest, sleekest airliners takeoff and land, wave to passengers, and eat at an upscale restaurant. (Port Authority of New York and New Jersey.)

IMAGES
of Aviation

LaGuardia
Airport

Joshua Stoff

ARCADIA
PUBLISHING

Published by Arcadia Publishing
Charleston SC, Chicago IL, Portsmouth NH, San Francisco CA

Printed in the United States of America

Library of Congress Catalog Card Number: 2008924409

For all general information contact Arcadia Publishing at:
Telephone 843-853-2070
Fax 843-853-0044
E-mail sales@arcadiapublishing.com
For customer service and orders:
Toll-Free 1-888-313-2665

Visit us on the Internet at www.arcadiapublishing.com

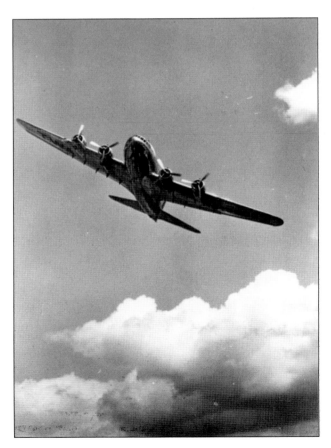

THE STRATOLINER OVER LAGUARDIA FIELD, 1940. This artistic view of a TWA (Trans World Airlines) Boeing Stratoliner cruising over LaGuardia Airport was taken by field photographer William Hoff. The Stratoliner represented the pinnacle of American commercial aviation just prior to World War II. (Cradle of Aviation Museum.)

CONTENTS

Acknowledgments 6

Introduction 7

1. Before LaGuardia: 1928–1939 9

2. The Beginning: 1939–1940 33

3. Taking Off: 1941–1950 79

4. Entering the Jet Age: 1951–1965 99

5. LaGuardia in the Modern Era: 1966– 115

ACKNOWLEDGMENTS

The author would like to thank the employees of the Port Authority of New York and New Jersey for their invaluable help in providing photographs for this work. When the author visited its archives in 2000, they were most generous in providing free copies of virtually any photograph needed. I wish I had copied more. This was a wonderful archive thoroughly documenting the history of all the airports serving New York from their inception. However, this archive was located on the 67th floor of Tower 1 of the World Trade Center and no longer exists.

Unless otherwise noted, all the photographs in this work come from the collection of the Cradle of Aviation Museum (CAM) in Garden City or the Port Authority of New York and New Jersey (PANYNJ). Special thanks to Tyler Stoff for his expert photography.

INTRODUCTION

In the fall of 1933, New York mayor Fiorello LaGuardia was flying home from vacation in Florida. On the final leg of his journey from Pittsburgh to New York, his TWA (Trans World Airlines) DC-2 landed at the only commercial airport to serve New York City—Newark Airport in New Jersey. Insisting his ticket said New York, LaGuardia refused to get off the plane. LaGuardia was demanding to be flown to New York City's airport, Floyd Bennett Field in Brooklyn, which then had no scheduled airline service. Eventually TWA relented, and the plane flew on to Brooklyn, but LaGuardia's stunt was successful, and it dramatically made the point that he wanted. New York, the epicenter of business and culture, was not served by any airlines.

By the late 1930s, commercial air transportation was coming of age in America, with more planes connecting more cities and with more passengers flying all the time. As some of the newer planes had greater ranges, commercial transoceanic flights even became feasible for the first time. But New York City and its unstoppable mayor were totally dissatisfied with the airport situation; its first attempt at a municipal airport, Floyd Bennett Field in Brooklyn, was a commercial failure. Floyd Bennett Field, which opened in 1931, was just too far from Manhattan, with no direct rail transportation or connecting highways. Not only would the airlines not service it, the post office also gave the lucrative New York airmail contract to the closer Newark Airport, a huge blow to the city.

Thus LaGuardia Airport was conceived in the late 1930s as the progressive mayor realized the need for a great airport for one of the world's great cities. LaGuardia campaigned relentlessly for a new airport, and he quickly decided on purchasing the privately owned Glenn Curtiss Airport, a general aviation field at North Beach, Queens. This airport, however small, was located only five miles from Manhattan on a new main highway near a subway line and had unobstructed water approaches—critical for the flying boats of the era.

The creation of LaGuardia Airport epitomizes how radically the federal government's role shifted in the development of new airports during the 1930s. New York's mayor became the first to get the federal government to build and pay for most of his. The federal government built LaGuardia Airport partly to create new jobs during the Depression and partly because it wanted to develop America's commercial air transportation system. In fact, the $40 million airport was the single largest project undertaken by the Works Progress Administration (WPA) up to that time.

To build the new airport at North Beach required an enormous landfill project, enlarging the existing field from 105 to 650 acres. Preliminary work began in late 1937, and by 1938, the project was proceeding at breakneck speed. The New York–based architectural firm Delano and Aldrich designed the terminals for the new airport, and what they came up with set the standard for many years to come. For the first time, arriving and departing passengers were separated on different levels. This allowed for the smooth movement and one-way flow of people in volume. The firm not only engineered efficient terminals but also designed them in a smart and instantly classic style. Terminal buildings were gracefully adorned with modern art deco details and incorporated

first-class restaurants and a rooftop viewing promenade for an excited public that then considered a busy airport as a unique form of family entertainment.

The new airport also had the latest technological innovations of the time. This included a state-of-the-art control tower with radio communications, current weather data and forecasts, and the first instrument-landing system in the world. Its two main runways of 5,000 feet were laid out in a T shape. They are still in use today although greatly extended to accommodate jets. At the time of its opening, this was the largest and most advanced commercial airport in the world. When it opened to great fanfare in the fall of 1939, it was truly America's first modern airport. Originally dubbed New York Municipal Airport, its name was soon changed to recognize LaGuardia's pivotal contribution to the project.

Immediately upon LaGuardia Airport's opening, the four airlines serving Newark Airport (American Airlines, TWA, United Air Lines, and Eastern Air Lines) relocated to the new airport in Queens. The post office also followed suit. The quick switch was clearly due to LaGuardia's outstanding new facilities and its closer proximity to midtown Manhattan. The effect on Newark's airport was immediate and devastating. It closed.

Although transatlantic flying boat service began at LaGuardia Airport in 1940, its glory days were short-lived. By 1946, the first scheduled transatlantic landplane flight was made when a Lockheed Constellation flew from LaGuardia to England in 12 hours. Considered a very large airport at the time it was built, by the late 1940s, LaGuardia became the world's busiest airport and was clearly too small for the amount of air traffic it was beginning to handle.

LaGuardia, during the 1950s, represented the pinnacle of the postwar boom in commercial aviation. In contrast to postwar fears of military aviation and a national fear of imminent nuclear attack, civil aviation at the time presented a positive—even glamorous—image to consumers finally ready to fly. Coach class fares became commonplace on domestic routes during the late 1940s and appeared on transatlantic routes during the 1950s. In 1951, domestic airline passengers exceeded railroad passengers for the first time, and by 1956, more travelers between America and Europe went by air than by ship. Nonetheless, for years after the end of the war, flying remained a comparatively expensive way to travel.

A visit to LaGuardia Airport in the early postwar era would have revealed an exciting, colorful place with waiting areas crowded with well-dressed travelers. Fancy airport restaurants were regarded as fine-dining establishments—a place to go and be seen. An afternoon spent on LaGuardia's Skywalk promenade just watching airliners takeoff and land was regarded as a fun day out. However, over time, the real or imagined glamour of air travel began to fade. The arrival of jets and deregulation in the 1960s established lower-priced economy fares that drew millions to air travel. The numbers and stifling crowds began a relentless upward spiral. But the image of the sleek, silver airliner established in the glamorous 1950s had become an accepted feature of contemporary American life—an iconic image of the air age that still remains.

Unlike other airports, LaGuardia began with limited surrounding land available to it, thus it entered the jet age only with great difficulty. Its runways were simply too short to handle jets, and there was little room for expansion. The only solution, unique to LaGuardia, was to add 2,000 feet to each runway (and taxiway) by building additions on reinforced steel piers extending into Flushing Bay. Nonetheless, LaGuardia still has the shortest runways of any major commercial airport in America.

In the mid-1960s, the original art deco Central Terminal, however aesthetic, was deemed too small to handle the volume of traffic LaGuardia was experiencing. It was demolished to make way for a large, new, modern glass-and-concrete terminal, and the popular Skywalk was now just a memory. A new 12-story, vase-shaped control tower also replaced the original, but this one was designed with some aesthetic appeal.

Ongoing renovations and improvements to the Central Terminal, additional terminals, and changes in airport layout have made LaGuardia Airport's operations more efficient in recent years. Now covering over 650 acres, LaGuardia handles some 26 million passengers per year, still ranking it as one of America's busiest airports.

One

BEFORE LAGUARDIA
1928–1939

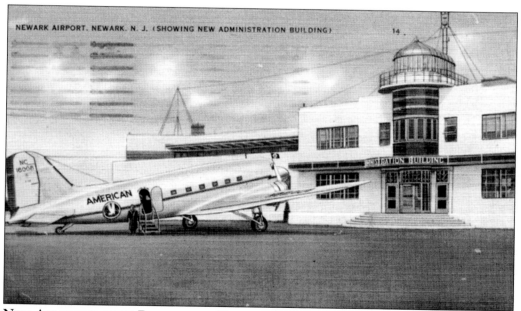

NEW ADMINISTRATION BUILDING AT NEWARK AIRPORT, C. 1935. Newark Airport was the first major airport in the New York area, opening on October 1, 1928. It occupied an area of New Jersey marshland filled with dredged soil. By the mid-1930s, a third of all the world's air traffic traversed this facility. The administration building, seen here, opened in 1935 and was North America's first commercial airline terminal. Newark had the first paved runway, first weather bureau, and first control tower. (CAM.)

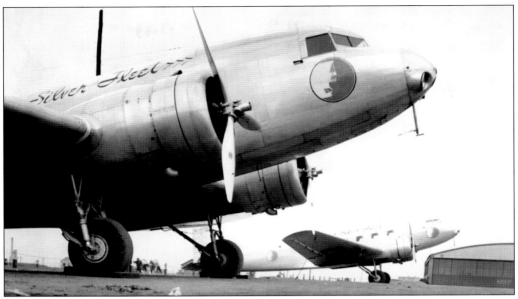

EASTERN AIR LINES DC-2S AT NEWARK AIRPORT, C. 1935. Due to its proximity to Manhattan, Newark was designated as the New York airmail terminus in 1929. Not only was the airmail contract lucrative, several major airlines quickly built their own hangars and terminals there, making this New York City's unofficial airport. It remained the world's busiest airport until LaGuardia opened in 1939. With the loss of the airmail contract and the relocation of all the airlines serving it, Newark Airport temporarily closed to commercial traffic in 1940. (CAM.)

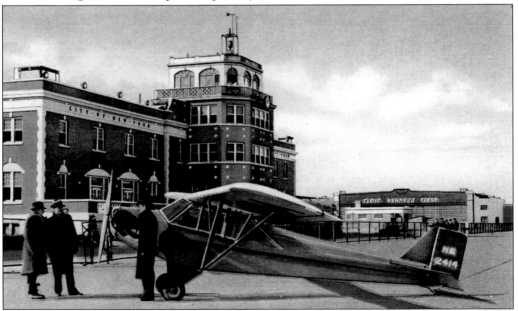

ADMINISTRATION BUILDING AT FLOYD BENNETT FIELD, C. 1936. In an attempt to develop its own city airport and compete with Newark Airport, New York City built its first municipal airport, Floyd Bennett Field, on marshland in Jamaica Bay, Brooklyn. Among the most advanced airports in the world when it opened in 1931, the airport only had one real problem—location. (CAM.)

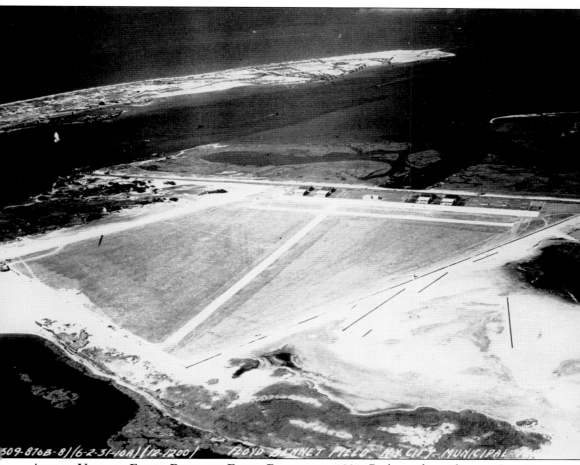

AERIAL VIEW OF FLOYD BENNETT FIELD, BROOKLYN, 1931. Built on the wide-open Jamaica Bay south shore of Brooklyn, the airfield featured the most modern of hangars and a beautiful new terminal building. However, the airport was just too far from Manhattan to ever be successful. At the time, there were no highways or direct rail service to connect the new airport to Manhattan. Thus the post office let Newark Airport continue to have the airmail contract, and no airlines moved to Floyd Bennett Field. (CAM.)

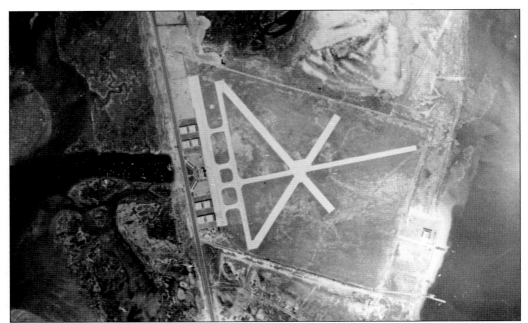

AERIAL VIEW OF FLOYD BENNETT FIELD, 1938. In an effort to attract airlines, the 3,000-foot paved runway system, a novelty at the time, was greatly expanded in the 1930s. The airport limped along as a generally unsuccessful civil airport until purchased and transformed into a naval air station in 1941. (CAM.)

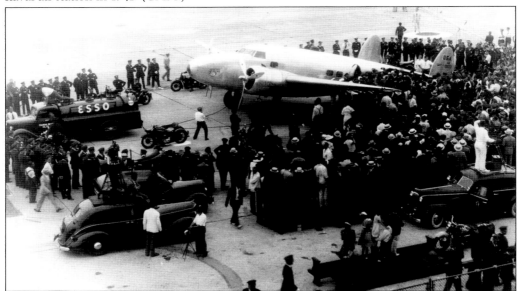

HOWARD HUGHES'S LOCKHEED AT FLOYD BENNETT FIELD, 1938. As a general aviation field, Floyd Bennett attracted the most famous record-setting pilots of aviation's golden age because of its superior, modern facilities and excellent location for flying. Thus many historic transcontinental or transatlantic flights of the 1930s began or ended at Floyd Bennett. Here Howard Hughes and his Lockheed Super Electra have just arrived at Floyd Bennett, having set a new around-the-world speed record. (CAM.)

JIMMIE MATTERN'S LOCKHEED VEGA AT FLOYD BENNETT FIELD, 1933. Here the field's state-of-the-art aircraft hangars form the backdrop for Jimmie Mattern's colorful Vega. Due to its facilities and the fact that it was in New York, the field was the ideal place for many historic flights. Mattern attempted to set an around-the-world speed record in this plane until he suffered an engine failure over Siberia. (CAM.)

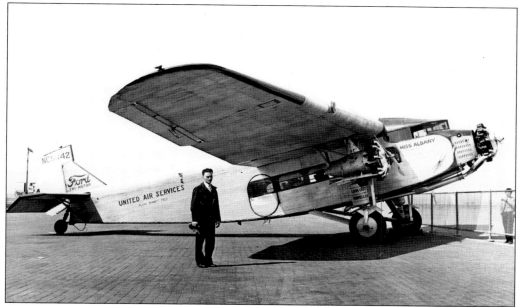

ARTHUR BUSSEY WITH UNITED AIR SERVICES FORD TRIMOTOR, 1932. One far-sighted attempt was made to establish a transatlantic airline at Floyd Bennett Field. United Air Services and its 4-AT Ford Trimotor equipped with long-range fuel tanks were seeking paying passengers on a proposed route to Harbour Grace, Newfoundland, and then on to London. Apparently there were no takers. (CAM.)

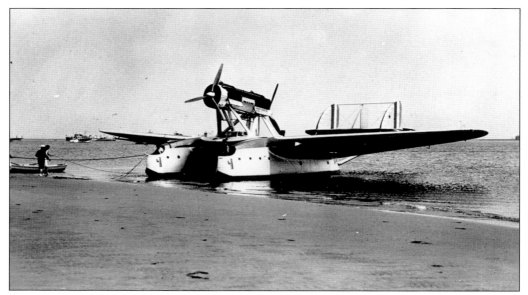

Italian Seaplanes in Jamaica Bay, 1933. The main reason New York's first municipal airport was built on the ocean was that the long-range aircraft of the day were almost all flying boats. These large, heavy aircraft required very long runways, so taking off and landing on expanses of water was necessary. This was clearly demonstrated at Floyd Bennett Field in July 1933, when a mass flight of 25 Italian Savoia Marchetti S-55 flying boats made the trip from Rome, Italy, to New York, landing in Jamaica Bay. (CAM.)

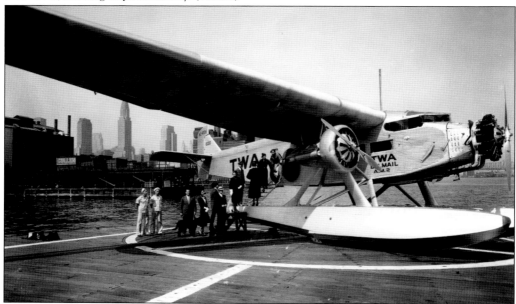

Ford Trimotor on Floats at Wall Street Seaplane Base, 1935. In a futile effort to lure airlines and customers to Floyd Bennett Field, New York mayor Fiorello LaGuardia talked TWA (Trans World Airlines) into starting a seaplane service from Manhattan. Thus TWA modified a 5-AT Trimotor, put it on EDO floats, and operated a shuttle service between the downtown skyport, the seaplane base at the foot of Wall Street, and Floyd Bennett Field. (CAM.)

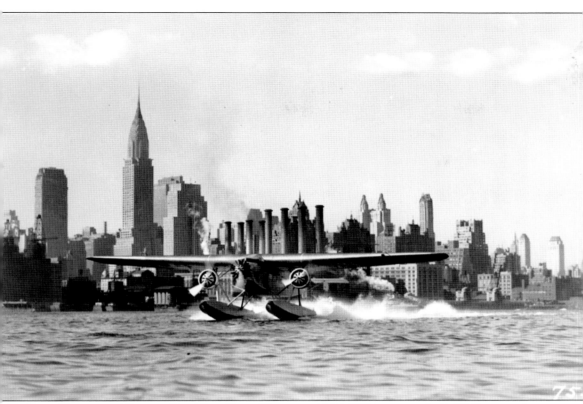

FORD TRIMOTOR TAKING OFF, NEW YORK HARBOR, 1935. TWA operated a 5-AT Trimotor for this service, having improved performance and more capacity than the earlier Trimotor model. However, the post office refused to move the mail contract from Newark Airport, and no airlines relocated to Floyd Bennett Field. Thus TWA's seaplane service only operated for a few months in 1935. (CAM.)

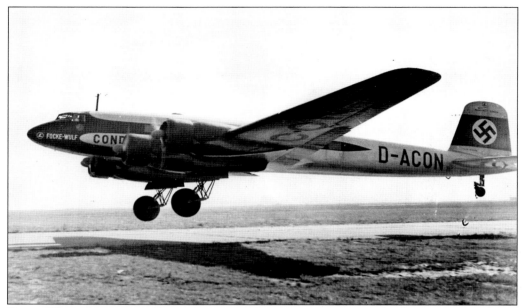

FOCKE WULF CONDOR AT FLOYD BENNETT FIELD, 1938. Presaging the future of transatlantic flight and the New York airports, the first land-based airliner to fly from Europe to America was a Lufthansa Airlines Focke Wulf Condor. In August 1938, the aircraft made a survey flight, carrying no passengers, nonstop from Berlin, Germany, to Floyd Bennett Field. Two days later, the aircraft made the nonstop return flight to Berlin in just under 20 hours. (CAM.)

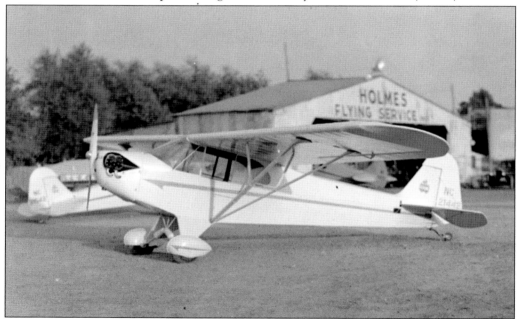

PIPER CUB AT HOLMES AIRPORT, 1938. The first attempt at a general-aviation commercial airport within the limits of New York City was Holmes Airport in Jackson Heights, Queens. Founded in 1928, the field was unique in that it had facilities for both airplanes and airships. The 220-acre field was dirt with gravel runways, but it was only five miles due east of Times Square. (CAM.)

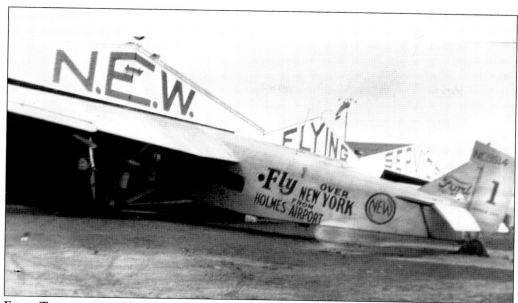

FORD TRIMOTOR AT HOLMES AIRPORT, 1929. The first airline to operate from within New York City was Eastern Air Express, which operated a Ford Trimotor on a two-day run to Miami beginning in 1929. Due to the expense and lack of interest, the service was short-lived, and by 1931, the Trimotor was solely used for sightseeing rides over New York City. (CAM.)

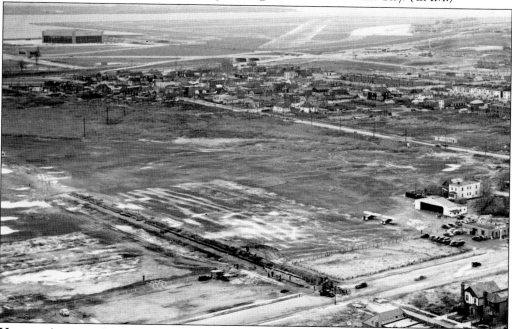

HOLMES AIRPORT, LOOKING SOUTHEAST, 1939. The quaint, crude Holmes Airport can be seen in the foreground, while in the rear, the newly built New York Municipal (LaGuardia) Airport has just been completed. The Marine Air Terminal can be seen at the left rear, LaGuardia's runway is in the center, and Hangar Row is at right rear. For about six months, the two airports operated side by side. (CAM.)

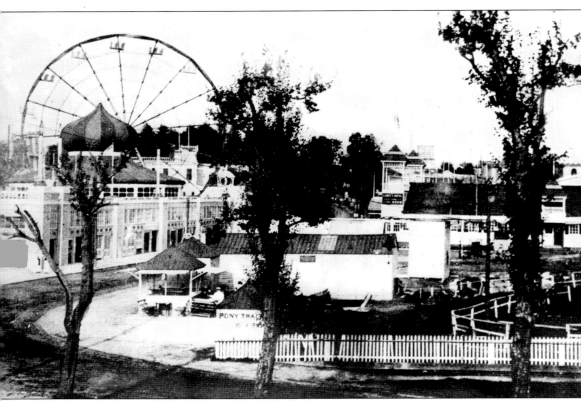

GALA AMUSEMENT PARK AT NORTH BEACH, QUEENS, 1892. Between 1890 and 1925, North Beach, a peninsula jutting out from Queens into Flushing Bay, was the site of a popular amusement park. Several trolley and rail lines brought people from Manhattan and Queens to visit the park on pleasant summer days. These rail lines were later important in the development of a major airport here. (PANYNJ.)

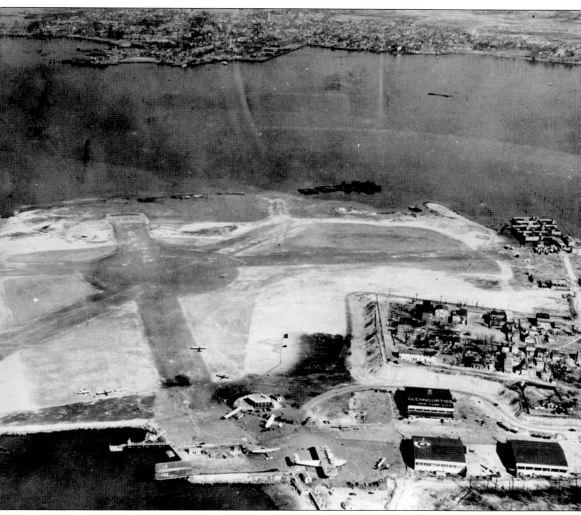

GLENN CURTISS AIRPORT AT NORTH BEACH, QUEENS, 1932. In the mid-1920s, the Curtiss-Wright Corporation bought the North Beach peninsula and developed Glenn Curtiss Airport there, a 200-acre general aviation field. In operation between 1928 and 1937, the airfield was built on waterfront property so that it could service both landplanes and the then-common seaplanes. It had three compressed gravel, 2,300-foot runways, three hangars, radio communications, and was lighted for night operations. (PANYNJ.)

LOCKHEED SIRIUS AT NORTH BEACH, 1937. The 120-foot-wide hangars at North Beach were state of the art for 1929. More than 70 planes were based here, many of them owned by wealthy sportsmen from Manhattan, Westchester, and Queens Counties. One of the main attractions of the field was that it was 15 minutes by speedboat from the 42nd Street marina and could be reached by subway or automobile from Times Square in about 30 minutes. These were huge considerations in the mid-1930s when Mayor Fiorello LaGuardia was seeking a site for a new municipal airport. (CAM.)

FORD 4-AT TRIMOTOR AT NORTH BEACH, 1931. One effort at airline operations was attempted at North Beach when the Curtiss-Wright Flying Service operated two Ford Trimotors here in 1931 and 1932. The two planes had hourly departures to Floyd Bennett Field, Newark, Atlantic City, and on occasion to Philadelphia. In spite of carrying many thousands of passengers without incident, Curtiss-Wright was unable to make a go of the service financially. (CAM.)

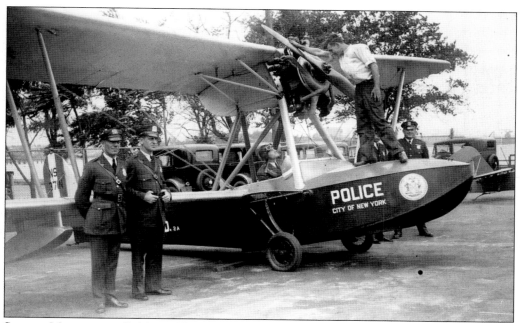

SAVOIA MARCHETTI S-56 AT NORTH BEACH, 1930. The City of New York also based its squadron of five aircraft at North Beach. Consisting of Keystone and locally built Savoia Marchetti amphibians, the planes were used by the police for patrol and rescue work in the early 1930s. (CAM.)

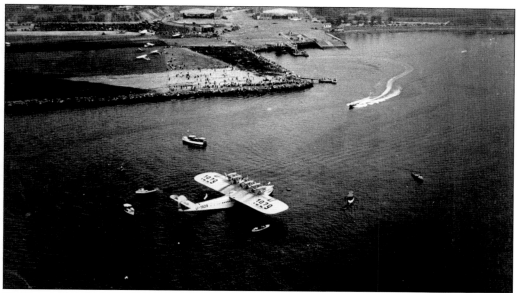

DORNIER DO-X ARRIVING AT NORTH BEACH AIRPORT, AUGUST 1931. The most historic flight to take place at North Beach occurred when a German flying boat, the Dornier DO-X, made an experimental survey flight from Germany to New York via South America. The badly underpowered aircraft was a tourist attraction at North Beach for nearly a year while its engines were exchanged for more powerful American ones for the return journey, which took place in May 1932. (CAM.)

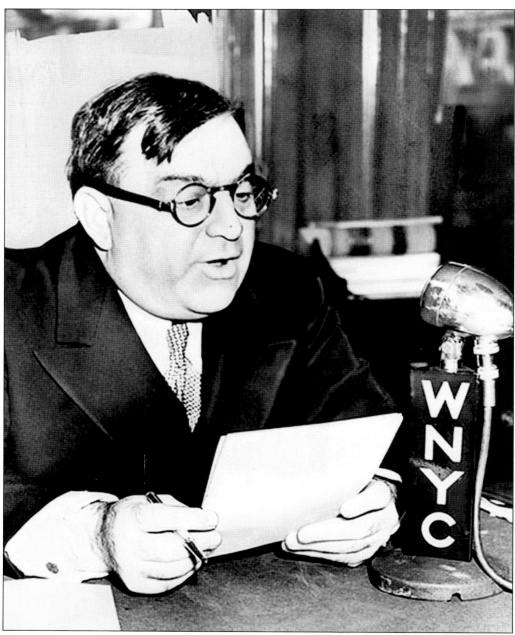

MAYOR FIORELLO LAGUARDIA, C. 1945. Born in New York of Italian parents, Fiorello LaGuardia (1882–1947) had a lifelong interest in both aviation and politics. First elected to the House of Representatives in 1916, in 1917 he joined the U.S. Army Air Service and served as a bomber pilot on the Italian front during World War I. LaGuardia was an extraordinarily popular New York City mayor between 1933 and 1945, where, as a fusion candidate, he developed a reputation as an honest and efficient administrator. (CAM.)

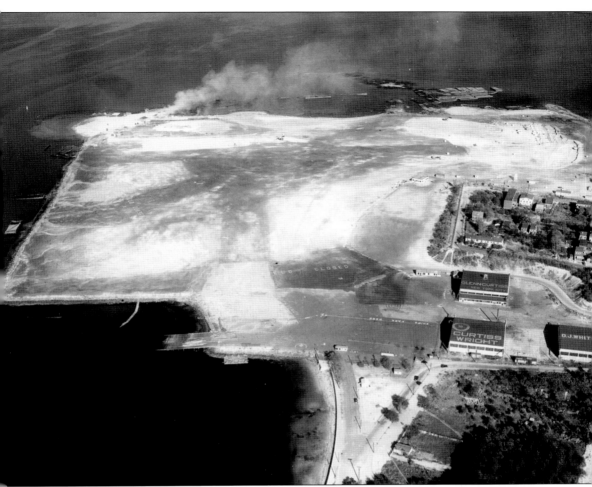

NORTH BEACH AIRPORT, LOOKING SOUTH, 1937. LaGuardia firmly believed in the need for the world's greatest airport for the world's greatest city. After his outburst over the arrival of his flight in Newark, not New York, LaGuardia set his sights on a much closer location for an airport to Manhattan than far-off Floyd Bennett Field. The site he selected was Glenn Curtiss Airport at North Beach next to a subway line and the newly built Grand Central Parkway, and it was on the water so it could service both landplanes and flying boats. The city purchased the site in 1937 and developed plans for a truly grand airport. North Beach is seen here in 1937 after the old airport was closed and construction of the new field had yet to begin. (Federal Aviation Administration.)

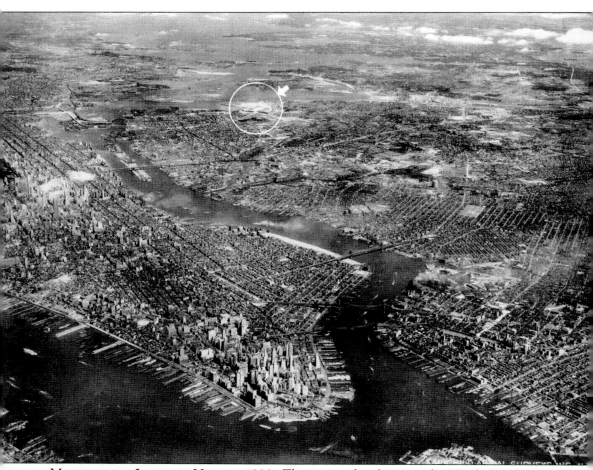

MANHATTAN, LOOKING NORTH, 1939. The reason for choosing the North Beach site is self-evident in this period photograph. The site of the airport is circled in the top center, and Central Park can just be seen at the left edge of the photograph. The new airport was less than 30 minutes from Manhattan by car, boat, train, or bus. (CAM.)

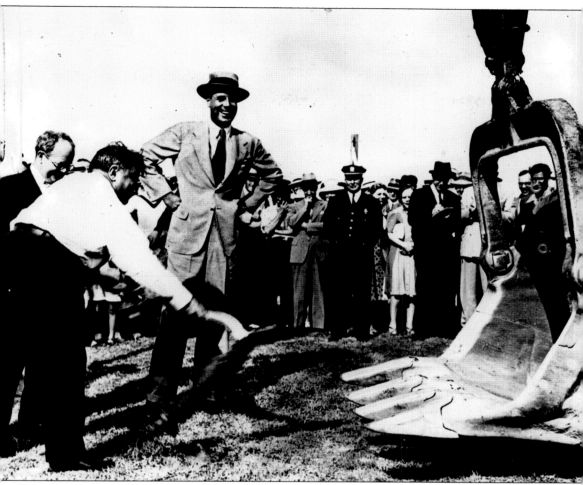

GROUNDBREAKING, SEPTEMBER 9, 1937. Although originally elected as a Republican, the pragmatic Fiorello LaGuardia supported Pres. Franklin D. Roosevelt and the New Deal. Thus LaGuardia developed plans for his grand airport with the New York Department of Docks and the architectural firm of Delano and Aldrich. Needing federal support to pursue his dream, LaGuardia approached Roosevelt, and on September 3, 1937, Roosevelt approved the construction of the new airport as a project of the WPA. Wasting no time, LaGuardia lifted the first shovelful of dirt on September 9. (PANYNJ.)

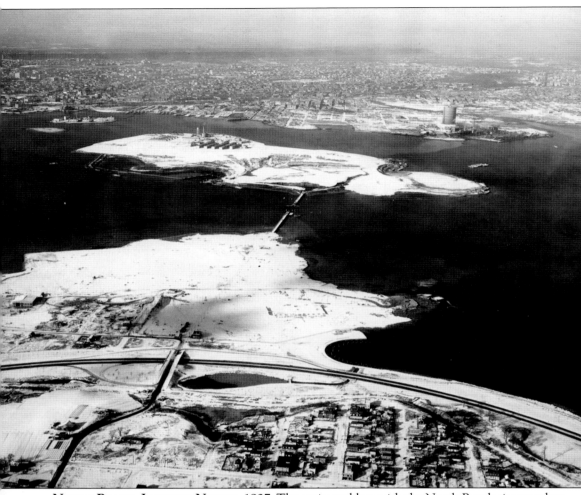

NORTH BEACH, LOOKING NORTH, 1937. The main problem with the North Beach site was that it would have to be an enormous landfill project to enlarge the small peninsula into a 550-acre modern airport. Thus a trestle, seen here, was temporarily built from Rikers Island (then a city garbage dump) over Bowery Bay so it could be used to transport nearly 15 million cubic yards of rubbish. By early 1939, over 5,000 workers were on the job working three shifts, six days a week. (Federal Aviation Administration.)

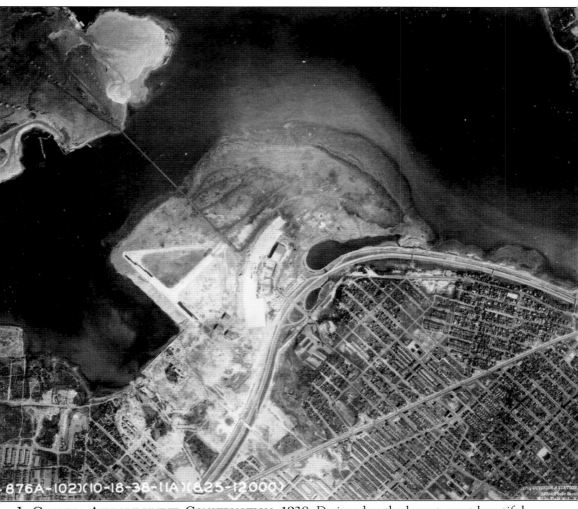

876A-102)(10-18-38-11A)(825-12000)

LAGUARDIA AIRPORT UNDER CONSTRUCTION, 1938. Designed as the largest, most beautiful, and most advanced civil airport in the world, work on the new airfield progressed rapidly. Even before the project was completed, Fiorello LaGuardia won commitments from all the airlines based at Newark Airport, as well as the post office, to make the switch. Here the runways are just taking shape and the crescent formed by the new terminal and hangars can be seen. The airport was separated from the Grand Central Parkway by a boat basin, here being dredged, so passengers could have direct ferry service to and from Manhattan. (CAM.)

27

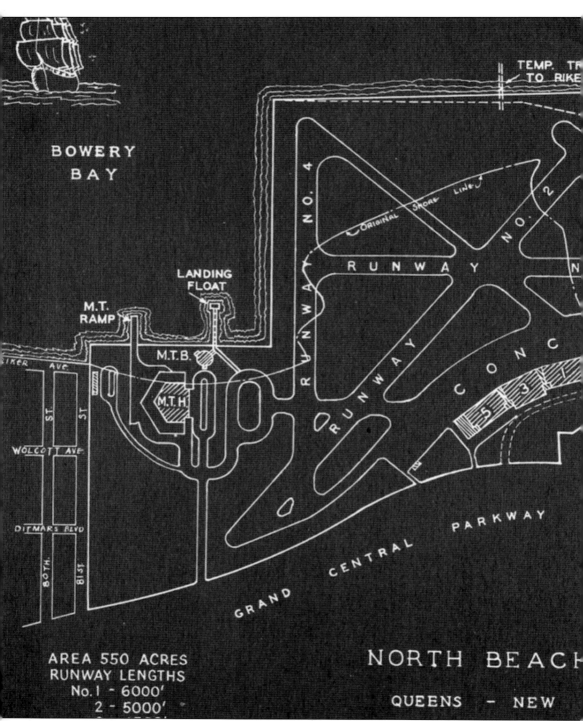

BOWERY BAY

TEMP. TR
TO RIKE

LANDING
FLOAT

M.T.
RAMP

M.T.B.

M.T.H.

RUNWAY NO. 4

Original Shore Line

RUNWAY

RUNWAY NO. 2

N

CONC

5 3 1

RUNWAY

WOLCOTT AVE.

DITMARS BLVD.

80TH ST.

81ST ST.

RIKER AVE.

GRAND CENTRAL PARKWAY

NORTH BEACH

QUEENS - NEW

AREA 550 ACRES
RUNWAY LENGTHS
No. 1 - 6000'
2 - 5000'

ORIGINAL PLAN OF NEW YORK MUNICIPAL AIRPORT, 1939. LaGuardia Airport was originally designed to be two airports in one: a landplane base and a seaplane base, each with its own terminal. Here the location of the Marine Terminal (MTB) can be seen on the left, bordering

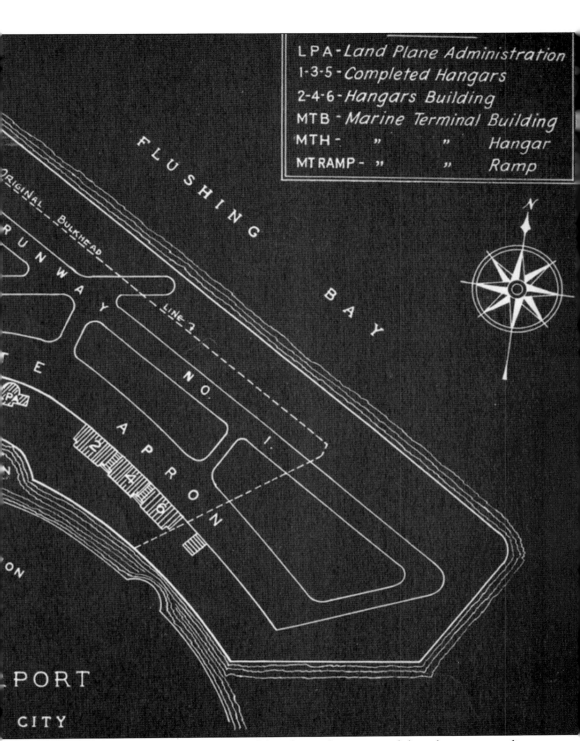

on Bowery Bay, and the Landplane Terminal (LPA) is in the center with large hangars spreading to the sides. Although built with four runways, only the two longest, at 5,000 feet each, were in regular use. (CAM.)

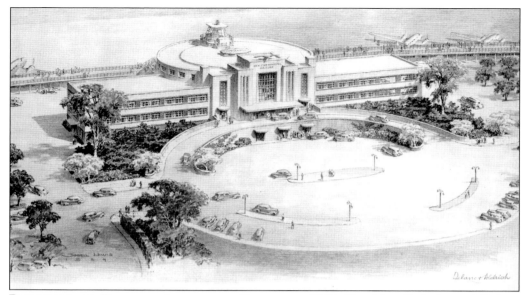

RENDERING OF PROPOSED LANDPLANE TERMINAL, 1937. The New York firm of Delano and Aldrich got the contracts for both terminals; previously they designed terminals for Pan American Airways. The terminals they designed are considered art deco masterpieces, and the Landplane Terminal, seen here, was the prototype for the modern air terminal. For the first time, arriving and departing passengers were separated on different levels, thus ensuring the smooth one-way flow of passengers. (CAM.)

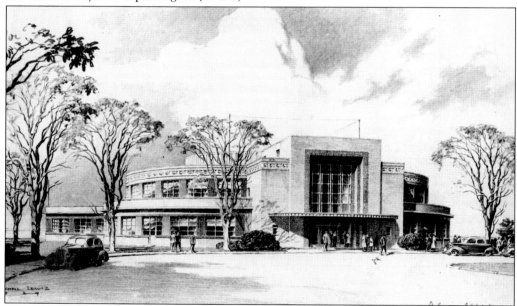

RENDERING OF PROPOSED MARINE AIR TERMINAL, 1937. On the other side of the field from the Landplane Terminal, Delano and Aldrich modeled the Marine Air Terminal on the Roman Pantheon. The round-domed building, with a frieze of flying fishes, was topped by a central skylight illuminating the interior. These two renderings were part of the proposal Pres. Franklin D. Roosevelt approved in order to fund the new airport. (CAM.)

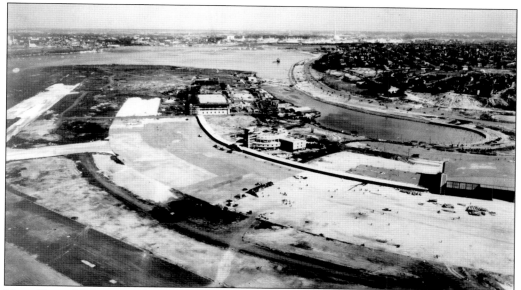

NEW YORK MUNICIPAL AIRPORT, LOOKING SOUTH, SPRING, 1939. By the time they were done, workers delivered over 17 million cubic yards of fill to reclaim 357 acres of the new 558-acre site. In all, it cost $40 million to create the airport, with about two thirds paid for by the federal government. In the distance can be seen the 1939 New York World's Fair. It was hoped the airport would be completed in time for the fair's opening. It was not, but it was completed the same year. (CAM.)

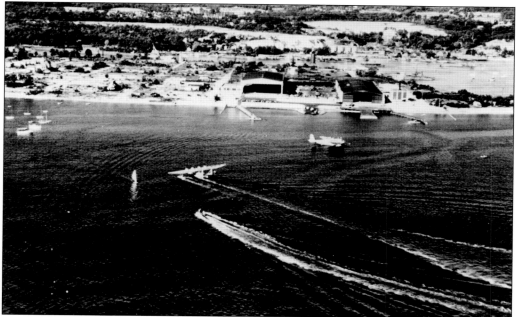

PORT WASHINGTON SEAPLANE BASE, 1938. Prior to the opening of New York Municipal Airport, between 1937 and 1939, Pan American Airways operated its flying boat base at Port Washington, Manhasset Bay, on Long Island's north shore. Here huge seaplanes made regular flights to both Bermuda and Europe. (CAM.)

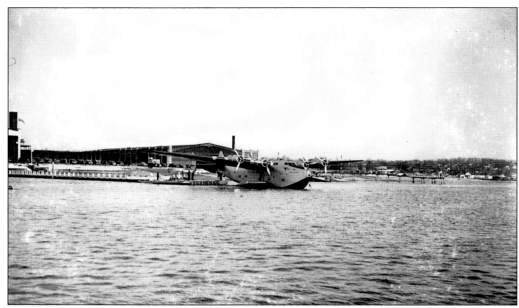

BOEING B-314 FLYING BOAT, PORT WASHINGTON, 1939. Pan American Airways began its transatlantic service at the beginning of 1939, using the spectacular new Boeing B-314 flying boats. These were the largest and most luxurious flying boats ever put into service. Pan American's first flight from here departed on May 20, 1939, bound for Southampton, England via the Azores. (CAM.)

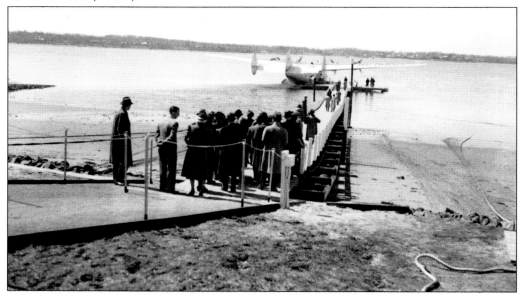

YANKEE CLIPPER ARRIVING IN PORT WASHINGTON, 1939. In spite of its extraordinarily expensive all-first-class service, virtually all of Pan American Airway's transatlantic flights were sold out, a luxury enjoyed by only the rich and famous. The four-engine B-314s had separate sleeping, dining, and recreation compartments, enjoyed by the 34 passengers on board. By the beginning of 1940, Pan American moved its transatlantic operations to the spectacular new Marine Air Terminal at New York Municipal Airport. (CAM.)

Two

THE BEGINNING
1939–1940

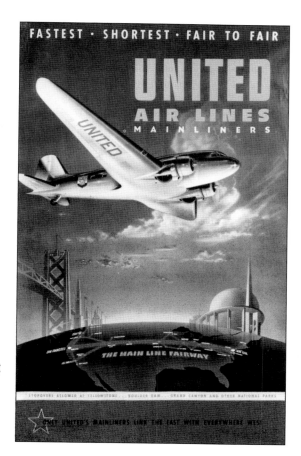

UNITED AIR LINES ADVERTISING POSTER, 1939. When construction of the new airport began, it was hoped its opening would coincide with the opening of the 1939 New York World's Fair. In spite of nearly round-the-clock work, it missed this goal by several months. In 1939, San Francisco also had a smaller and less noteworthy world's fair. (CAM.)

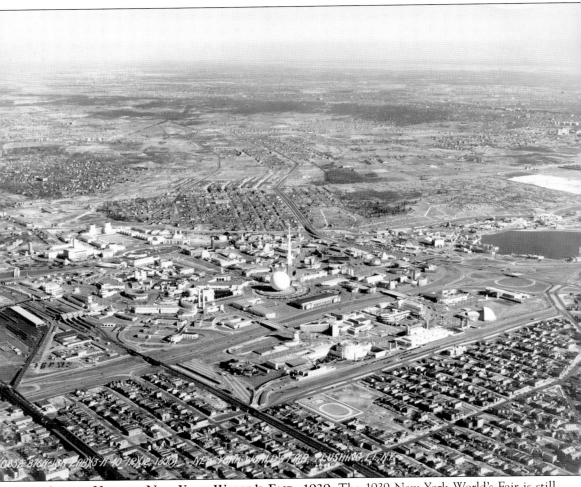

AERIAL VIEW OF NEW YORK WORLD'S FAIR, 1939. The 1939 New York World's Fair is still hailed as being the most architecturally spectacular and visionary world's fair ever held. Filled with noteworthy art deco structures and visions of the world to come, it was located two miles from New York Municipal Airport. (CAM.)

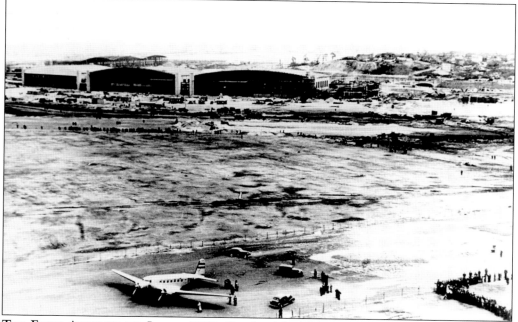

THE FIRST AIRLINER TO LAND, 1939. On April 2, 1939, a TWA DC-2 landed at the new airport while most of it was still under construction. The flight was basically a test of the new runways and taxiways, but nonetheless, it still attracted a crowd. (CAM.)

Program of Events

NEW YORK

MUNICIPAL AIRPORT

Dedication

NORTH BEACH, LONG ISLAND

SUNDAY, OCTOBER FIFTEENTH, 1939

PROGRAM COVER, NEW YORK MUNICIPAL AIRPORT DEDICATION. Fortunately for all parties concerned, October 15, 1939, turned out to be a perfect day. Opening festivities featured several short speeches and a simple ceremony. Wisely the action centered on a spectacular display of the latest military and civilian aircraft. (CAM.)

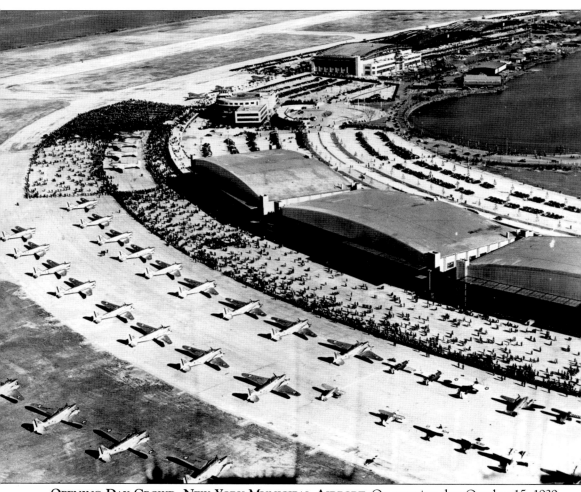

OPENING DAY CROWD, NEW YORK MUNICIPAL AIRPORT. On opening day, October 15, 1939, the airport was mobbed by a crowd of 325,000. This was by far the largest crowd to ever visit an airport in one day. Although christened as New York Municipal Airport, while the ceremonies were going on, a skywriting plane wrote overhead, "Name it LaGuardia." (CAM.)

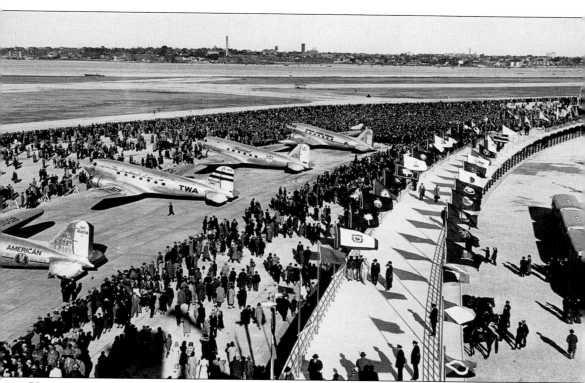

VIEW OF THE AIRLINERS AND SKYWALK, OCTOBER 15, 1939. The first aircraft to arrive were gleaming DC-3s from American Airlines, TWA, United Air Lines, and Canadian Colonial Airways bringing various dignitaries. A Pan American Airways Boeing B-314 made a low pass overhead and landed in adjacent Bowery Bay. (CAM.)

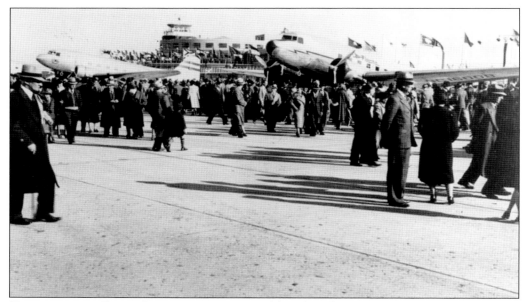

VIEW FROM THE FIELD, OPENING DAY, 1939. Although a glorious day for New York Municipal Airport, the arrival of these new airliners spelled doom for Newark Airport. With the airlines' abandonment, it closed within weeks. Opening day was also the first and last time such a crowd was allowed onto the flight line at LaGuardia. (CAM.)

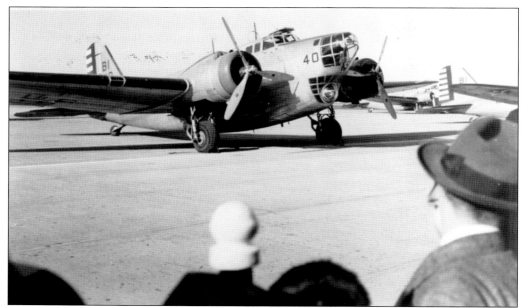

DOUGLAS B-18 AT NEW YORK MUNICIPAL AIRPORT, OPENING DAY. For the festivities, a squadron of B-18 bombers was flown in from nearby Mitchel Field on Long Island. Altogether 150 planes took part in the day's events. This was the only air show to ever take place at LaGuardia Airport. (CAM.)

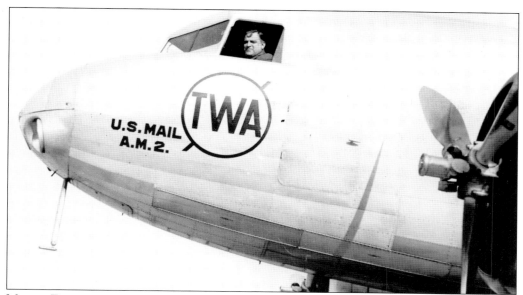

MAYOR FIORELLO LaGUARDIA IN THE COCKPIT OF A TWA DC-3, 1939. In his short speech on opening day, Fiorello LaGuardia said, "We are dedicating a giant airport to peace, to bring tidings of happiness to commerce, and friendly relations with all countries whose planes will land at this airport." The public campaign to change the name of the airport began immediately, and on November 2, 1939, the New York City Council passed a resolution adopting the name, New York Municipal Airport—LaGuardia Field. (PANYNJ.)

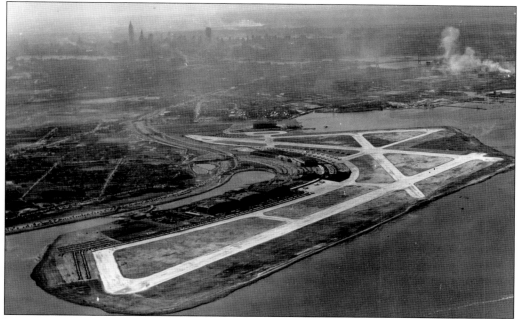

NEW YORK MUNICIPAL AIRPORT, LOOKING WEST, 1939. The close proximity of the airport to Manhattan, the reason for its being, is clearly evident. The boat basin separated the field from the Grand Central Parkway—a major new route so travelers could speed into Manhattan via the brand new Queens-Midtown Tunnel. (CAM.)

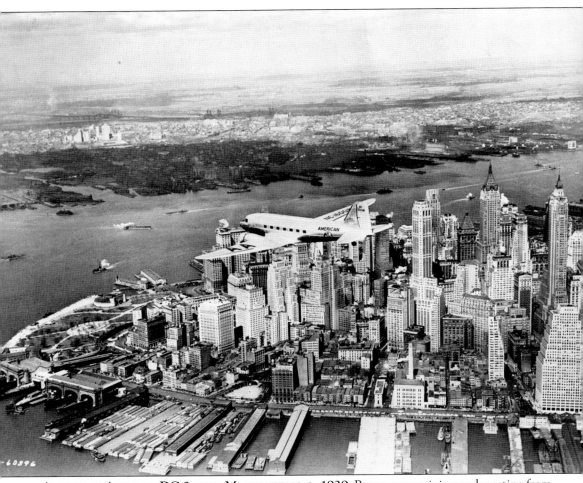

AMERICAN AIRLINES DC-3 OVER MANHATTAN, C. 1939. Passengers arriving or departing from LaGuardia Airport have always been treated to the spectacular sight of Manhattan at low altitude. In its early years, virtually all aircraft operating from LaGuardia were Douglas DC-3s. (CAM.)

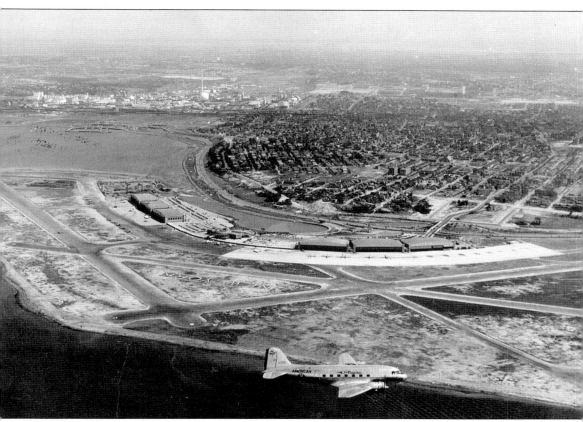

AMERICAN AIRLINES DC-3 OVER LAGUARDIA FIELD, C. 1939. The DC-3, first flown in 1935, was the plane that popularized air travel in the United States. By all standards, it was a safe, reliable, and economical aircraft. With over 10,000 built, the speed and range of the DC-3 revolutionized air transport in the late 1930s. Note "New York" spelled out between the runways, a feature retained to this day. The world's fair can be seen across Flushing Bay. (CAM.)

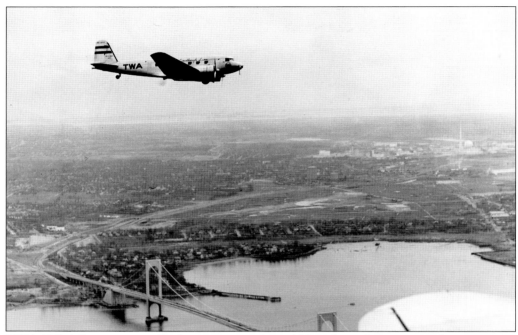

TWA DC-2 INBOUND TO LAGUARDIA, C. 1939. Although no longer in production, many DC-2s were still in regular service in 1940. The earlier model DC-2 seated 14, as compared to 28 in the DC-3. The Bronx-Whitestone Bridge and world's fair are also visible. (CAM.)

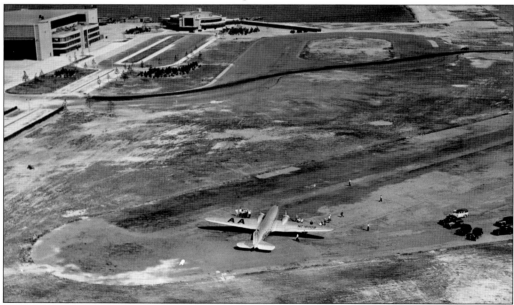

AMERICAN AIRLINES DC-3 ON LAGUARDIA FIELD, C. 1939. The DC-3 was powered by two 1,100-horsepower Wright Cyclone engines, and it cruised at 150 miles per hour. DC-3s had a range of just over 1,000 miles, so flights from New York to California could now be made in 15 hours, with two or three refueling stops in between. In the distance can be seen the Marine Air Terminal and the enormous flying boat maintenance hangar. (CAM.)

TWA Flight Crew at LaGuardia Field, c. 1939. On the left is air hostess, or stewardess, Miss Sisson, and on the right is J. L. Magdan, the copilot. At the time, airlines had very strict rules regarding the appearance and performance of stewardesses. The first stewardess was hired by United Air Lines in 1930. (CAM.)

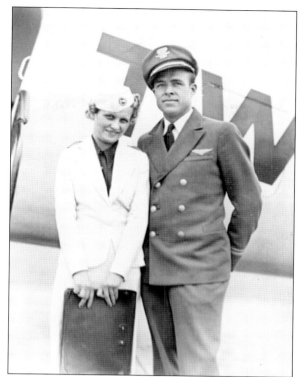

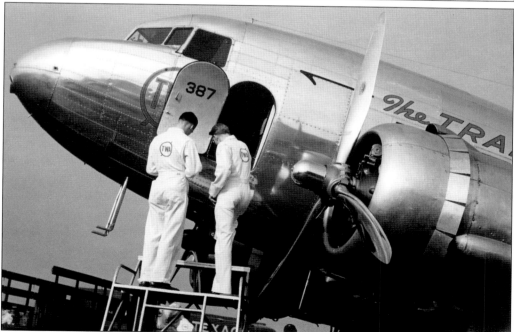

Mechanics Servicing TWA DC-3, LaGuardia Field, c. 1940. At the time of its opening, LaGuardia Airport by far had the best facilities for servicing aircraft of any commercial airport in the United States. (CAM.)

43

MECHANICS SERVICING EASTERN AIR LINES DC-2, LAGUARDIA FIELD, C. 1940. The DCs were almost invariably kept with a polished aluminum exterior. This both looked spectacular and saved weight due to the lack of paint. (CAM.)

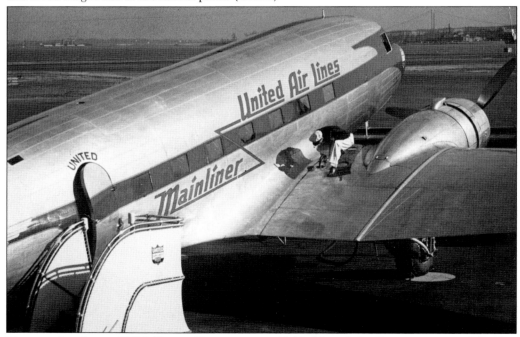

UNITED AIR LINES DC-3 BEING REFUELED, C. 1940. United Air Lines was one of the first airlines to service LaGuardia Airport in 1939, and it shared hangar space with Canadian Colonial Airways. The fabric-covered air stairs are of note. (CAM.)

EASTERN AIR LINES DC-3 UNDERGOING PROPELLER ADJUSTMENT, C. 1940. Up to 12 DC-3s could be fit into each of LaGuardia Airport's huge hangars, the largest in the world at the time. Complete maintenance facilities here included machine shops that both manufactured and repaired parts and overhauled instruments and complete engines. (CAM.)

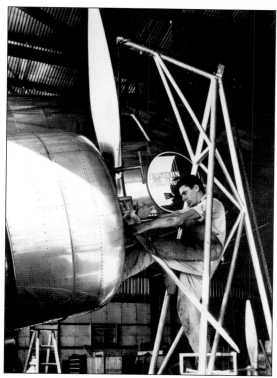

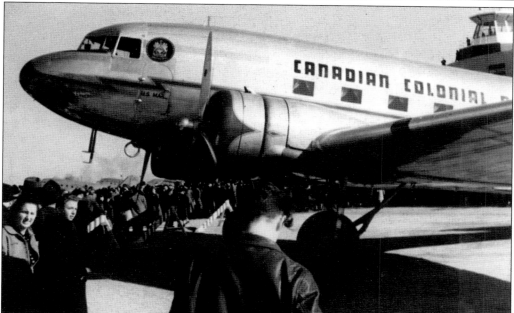

CANADIAN COLONIAL AIRWAYS DC-3 AT LAGUARDIA FIELD, C. 1940. Canadian Colonial Airways was also one of the original airlines to service LaGuardia Airport. Founded in 1929, it was headquartered in Montreal. It became Colonial Airlines in 1942 and was bought out by Eastern Air Lines in 1956. (CAM.)

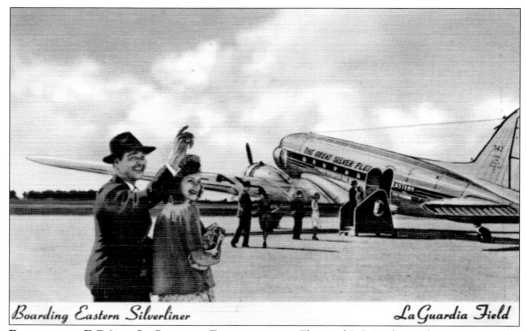

Boarding Eastern Silverliner *La Guardia Field*

BOARDING A DC-3 AT LAGUARDIA FIELD, C. 1940. Fleets of DC-3s plying the airways in the late 1930s and early 1940s paved the way for the modern air-travel industry. It is certainly one of the most significant transports ever made. (CAM.)

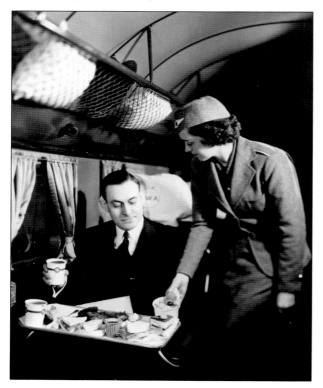

MEAL SERVICE ABOARD A TWA DC-2, 1939. In the 1930s and early 1940s, there was only one class of airline service—first. In an attempt to lure passengers, the airlines and their air hostesses were overly attentive to the travelers needs. All meals served aboard planes out of LaGuardia Airport were prepared on the field ahead of time by the Hotel New Yorker. (CAM.)

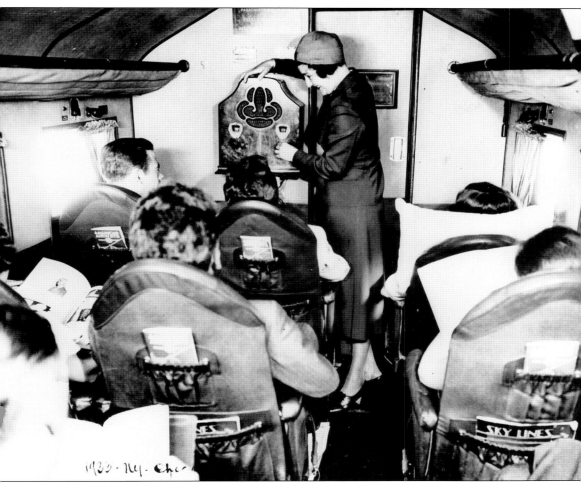

IN-FLIGHT ENTERTAINMENT ABOARD AN AMERICAN AIRLINES DC-3, C. 1937. Airline attempts to lure passengers in spite of the costs were clearly successful as the airplane replaced trains as the favored means of long-distance travel by the late 1940s. It is doubtful these passengers heard much of the radio between the engine noise, vibration, and cotton in their ears. (CAM.)

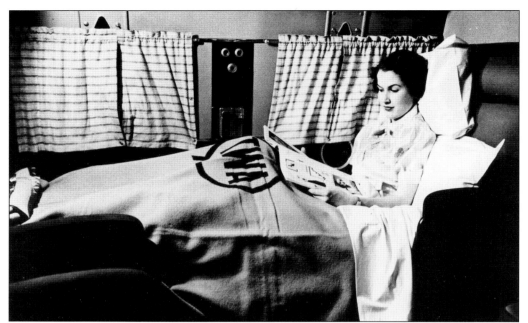

PREPARING FOR BED ABOARD A TWA DC-3, C. 1940. The Douglas Aircraft Company also produced an overnight version of the DC-3, called the DST (Douglas Sleeper Transport). This plane carried only 14 passengers on the 15-hour flight between New York and Los Angeles. Carrying only half the normal passenger load allowed each passenger to have their own sleeping berth. (CAM.)

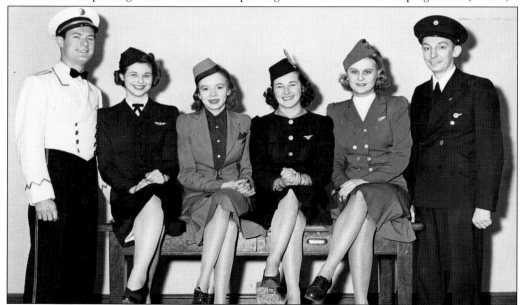

AIR HOSTESSES AND STEWARDS AT LAGUARDIA FIELD, 1940. In 1940, the Red Cross held a fund-raising fashion show at LaGuardia Field. Each of the airlines serving LaGuardia supplied one crew member to participate. From left to right are Edward Dillon, Eastern Air Lines; Jean Herbert, American Airlines; Mary Young, United Air Lines; Helen Phelan, Canadian Colonial Airways; Mary Dittman, TWA; and Anthony Patak, Pan American Airways. (CAM.)

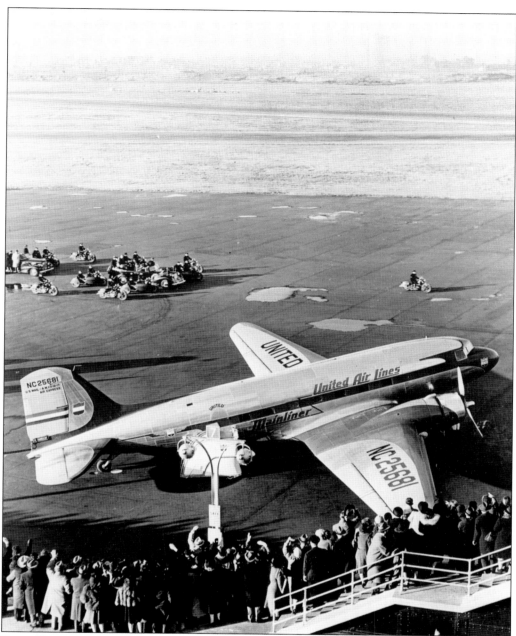

PRES. FRANKLIN D. ROOSEVELT VISITING LAGUARDIA FIELD, 1940. In the years before the president had his own airplane, a commercial airliner was chartered whenever the president needed to fly. Thus on April 16, 1940, Pres. Franklin D. Roosevelt flew to New York in a United Air Lines DC-3 to inspect the beautiful new airport. (PANYNJ.)

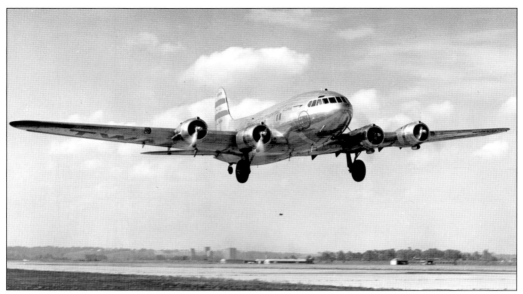

BOEING STRATOLINER INBOUND TO LAGUARDIA FIELD, 1940. The first big airplane to service LaGuardia Airport were TWA and Pan American Airways Boeing 307 Stratoliners in 1940. The Stratoliner is historic in that it was the first fully pressurized airliner to enter service anywhere in the world. Able to fly 20,000 feet higher than the 7,500-foot altitude unpressurized DC-3s normally flew at, this meant it could fly above bad weather and give a much smoother turbulence-free flight for passengers. (CAM.)

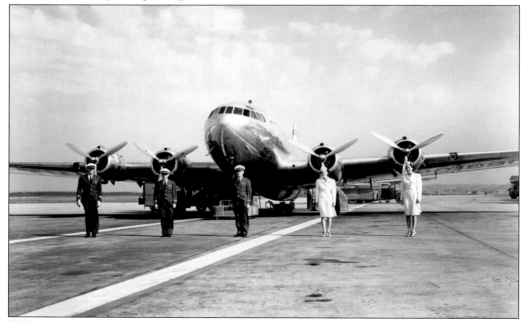

TWA STRATOLINER CREW AT LAGUARDIA FIELD, 1940. The Boeing Stratoliner carried five crew members and 33 passengers and had a nearly 12-foot wide cabin for overnight berths. The Stratoliner was also the first land-based airplane to have a flight engineer as a member of the crew. (CAM.)

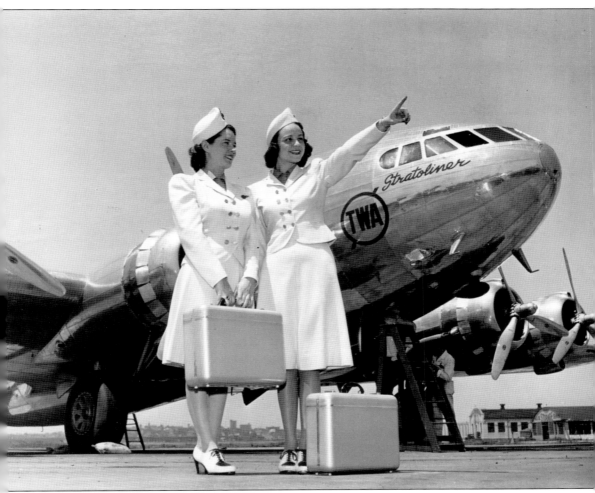

TWA BOEING STRATOLINER AIR HOSTESSES AT LAGUARDIA FIELD, 1940. Probably the most glamorous land-based airliner of the period, the Boeing 307 was basically a straight-forward variation of the B-17 Flying Fortress bomber. It cruised at 220 miles per hour with a 2,390-mile range. (CAM.)

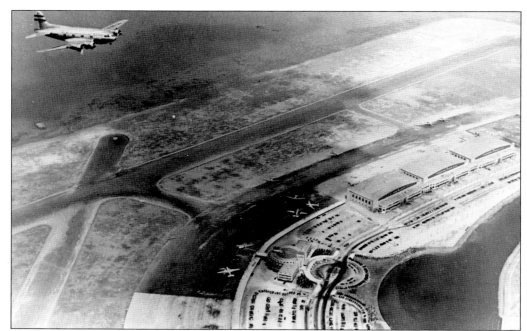

TWA STRATOLINER OVER LAGUARDIA FIELD, 1940. The Stratoliner first flew in 1938 and entered service in the summer of 1940. Due to its speed and ability to fly at high altitudes, it cut three hours off the DC-3s flight time between coasts. (CAM.)

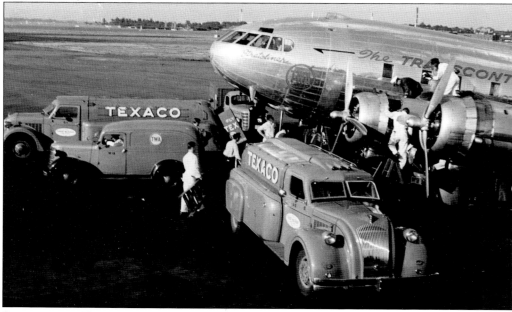

STRATOLINER BEING PREPARED FOR FLIGHT AT LAGUARDIA FIELD, 1940. Due to its cost, only nine Stratoliners were built. Three went to Pan American Airways for service to South America, five served TWA on the New York-to-California route, and Howard Hughes bought one. Here the plane is refueled, engines are checked, windows are cleaned, food is loaded, and a crew member inspects the plane, all simultaneously. (CAM.)

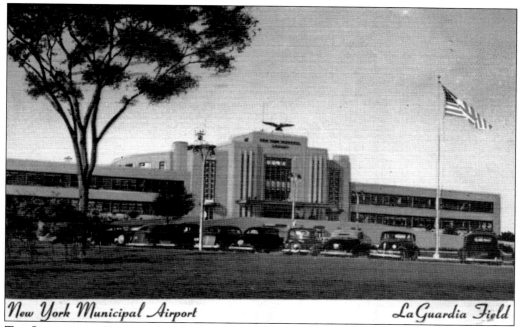

New York Municipal Airport — LaGuardia Field

THE LANDPLANE TERMINAL ADMINISTRATION BUILDING, C. 1940. The three-story building was built of buff-colored brick with black trim and striking art deco features. Above the entrance was a marquee of stainless steel with large, wrought iron–framed windows. (CAM.)

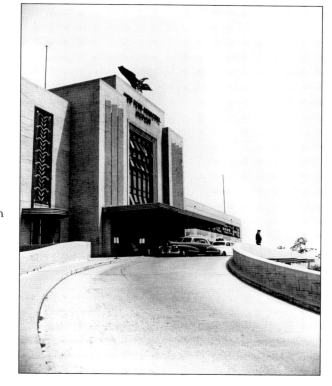

THE LANDPLANE TERMINAL, C. 1940. This was the first terminal in the world to separate arriving and departing passengers onto different levels for the more efficient flow of people and automobiles. A magnificent stainless steel eagle with a 17-foot wingspan, called the *Spirit of Flight*, was placed above the entrance. The sign over the entrance read, "New York Municipal Airport" until 1952. (CAM.)

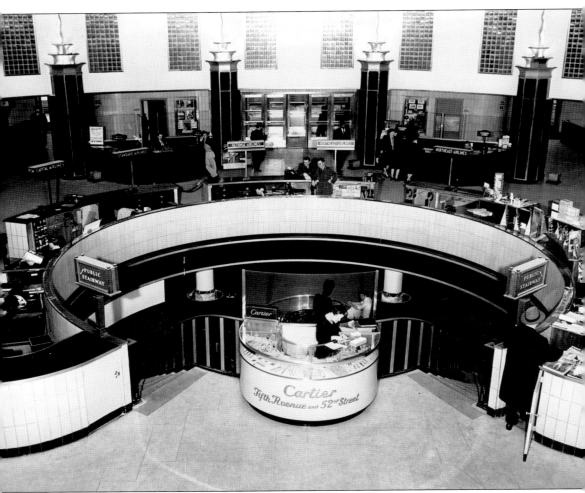

LANDPLANE TERMINAL LOBBY, C. 1940. Some of the striking art deco architecture can be seen here. Suspended overhead in the center was a giant globe of blue and gray set against a mural of the signs of the zodiac. Around the perimeter are airline ticket and check-in counters. One of the first airport shops can be seen in the center. Clearly at the time, only the wealthy could afford to fly. (PANYNJ.)

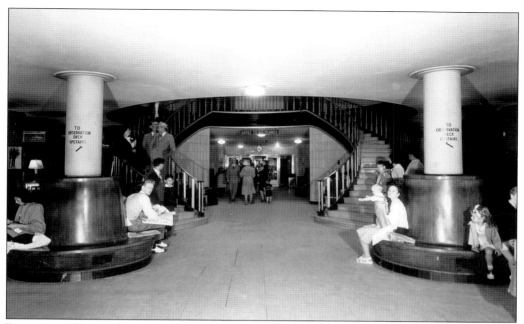

DEPARTURE LEVEL, LANDPLANE TERMINAL, C. 1940. Beneath the lobby was a separate level for departures. The circular staircase took people to the Skywalk observation deck, the large promenade where they could wave to arriving and departing friends and relatives or simply watch the exciting airport action. (PANYNJ.)

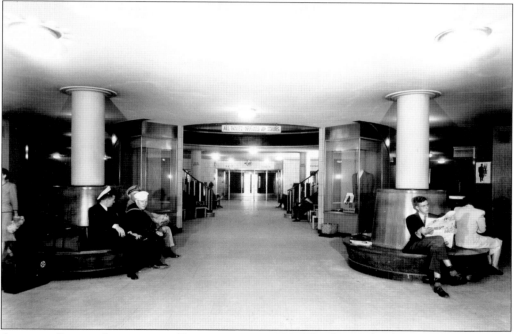

ARRIVAL LEVEL, LANDPLANE TERMINAL, C. 1940. The lowest level is where passengers arrived and entered the building. They could exit directly ahead to the street and its waiting taxis. (PANYNJ.)

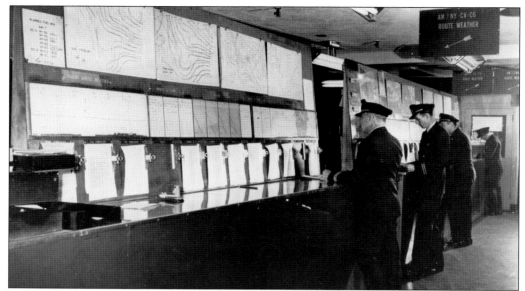

METEOROLOGY OFFICE AT LAGUARDIA FIELD, C. 1940. The Landplane Terminal at LaGuardia Airport also contained the eastern region headquarters of the Civil Aeronautics Authority (now the Federal Aviation Administration). From here, all air traffic in the northeastern United States was handled. The Civil Aeronautics Authority Meteorology Office here was also the most advanced of any airport in the country. Pilots made last minute checks of the en route weather prior to all departures. (CAM.)

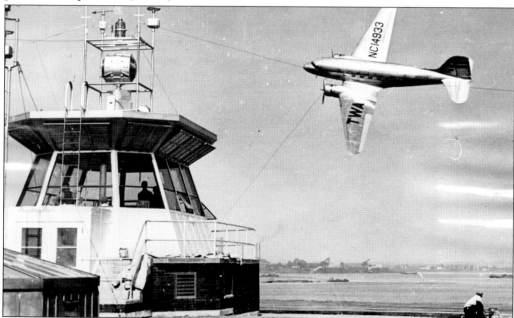

LAGUARDIA FIELD TOWER AND TWA DC-3, 1940. The control tower at LaGuardia Airport atop the Landplane Terminal bristled with the latest developments in radio, lighting, and meteorology equipment. The rotating beacon was 13.5 million candlepower, the most powerful in the world at the time. (CAM.)

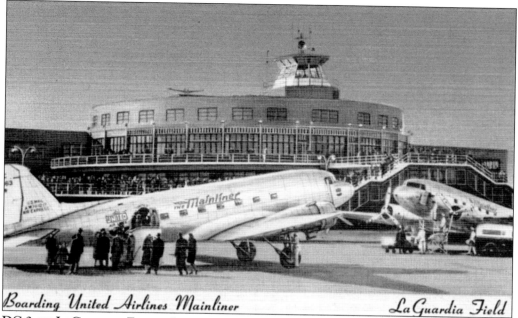

Boarding United Airlines Mainliner *La Guardia Field*

DC-3 ON LaGUARDIA FLIGHT LINE, C. 1939. The view from the airfield side of the Landplane Terminal can be seen in this period postcard. As this airport and all others at the time had no corridors, or Jetways, to the aircraft, passengers had to walk across the flight line from the terminal to get to their flight. (CAM.)

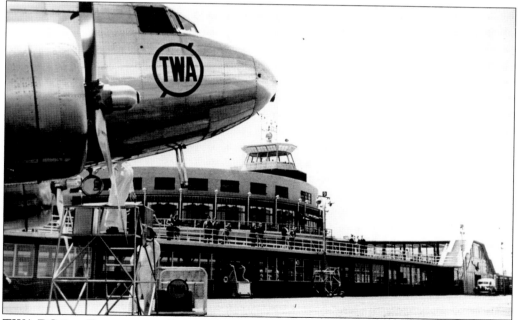

TWA DC-3 IN FRONT OF THE LANDPLANE TERMINAL, C. 1940. Passengers entered and exited the terminal through the field level. The observation deck, or Skywalk, was on top where friends and family could wave to the passengers. The large glass windows behind this housed LaGuardia Airport's fanciest restaurant. (CAM.)

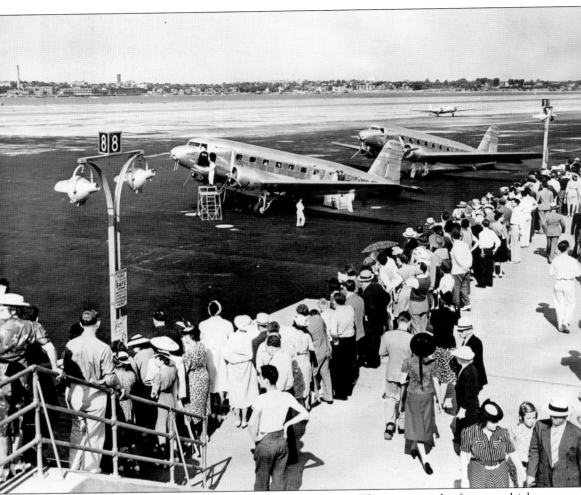

THE LAGUARDIA SKYWALK AND TWA DC-2S, C. 1939. The most popular feature, which was unique to this airport, was the Skywalk, where people outdoors and up close could watch sleek airliners arrive and depart. Not only was this used by people seeing off or picking up travelers, it was a hugely successful new form of entertainment for New York City. For a dime, a family could watch shiny airliners arriving from all over the country. Even if they could not afford to fly, they could still participate in this glamorous, new form of transportation. (CAM.)

LA GUARDIA AIRPORT RESTAURANTS

Grand Central Parkway • Jackson Heights, L. I.

(IN THE MAIN ADMINISTRATION BUILDING)

- **Aviation Terrace Restaurant**

 From its generous windows, an impressive view of the runways the year 'round. And during the summer, outdoor dining on the Terrace, open to the stars. . . . Complete luncheons from 75c; full course dinners from $1. . . . Dancing nightly.

- **Kitty Hawk Room**

 Inviting, intimate; its decorative scheme reminiscent of the early days of flying. Popular Circular Bar; music and entertainment at Cocktail Hour and throughout the evening. Cocktails from 25c; complete luncheons from 75c; full course dinners from $1.

- **The Coffee Shop**

 Quick table, counter and bar service. Club breakfasts from 25c; plate luncheons from 25c; budget dinners from 45c; Sunday dinners from 85c; popular-price a la carte service.

- **Private Parties Welcome**

 The luxurious appointments and subdued elegance of the Aviation Terrace Restaurant achieve an unusual and intriguing setting for large or small groups. . . . Let us help you plan your next social affair; no obligation. (Please make arrangements with the Sales Manager.)

ALL RESTAURANT FACILITIES AT LA GUARDIA FIELD OPERATED BY HOTEL NEW YORKER, NEW YORK

Frank L. Andrews, President

PRINTED IN U.S.A.

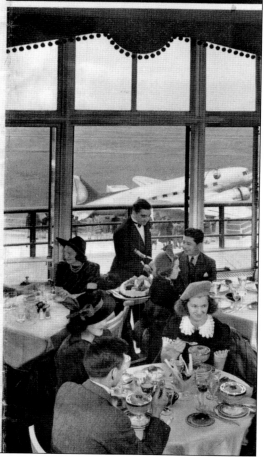

New Dining Thrill

LA GUARDIA AIRPORT RESTAURANTS

BROCHURE FOR LAGUARDIA FIELD RESTAURANTS, 1940. An upper floor of the Landplane Terminal housed several restaurants and a bar, all of them managed by the posh Manhattan-based Hotel New Yorker. (CAM.)

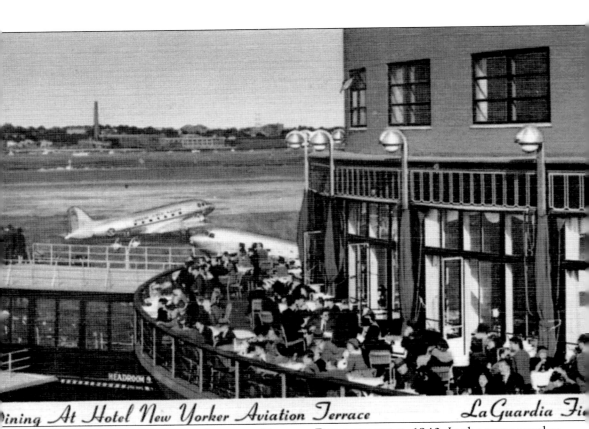

Dining At Hotel New Yorker Aviation Terrace — La Guardia Fie[ld]

OUTDOOR DINING AT THE AVIATION TERRACE RESTAURANT, C. 1940. In the warm weather months, the outdoor patio was a popular dining spot. From here, both the runways for landplanes and the bay for seaplanes could be seen. The restaurant was said to have a "box seat at the nation's biggest airshow." (CAM.)

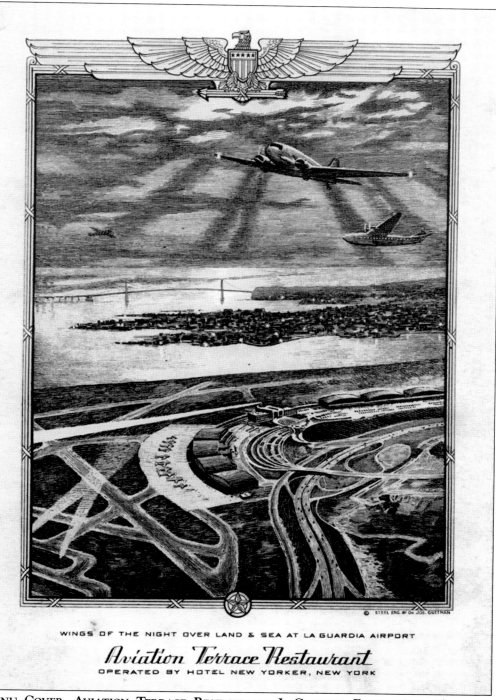

WINGS OF THE NIGHT OVER LAND & SEA AT LA GUARDIA AIRPORT

Aviation Terrace Restaurant

OPERATED BY HOTEL NEW YORKER, NEW YORK

MENU COVER, AVIATION TERRACE RESTAURANT, LAGUARDIA FIELD, 1939. The menu cover featured a steel engraving showing the airport layout with a DC-3 and Boeing flying boat overhead. In the distance can be seen the brand new Bronx-Whitestone Bridge and Long Island. (CAM.)

OYSTERS, CLAMS & APPETIZERS
Little Neck Clams, 35 Cherrystone Clams, 40
Bluepoint Oysters, 35 Cape Cod Oysters, 40
Hearts of Celery, 30 Shrimp Cocktail, 55
Fruit Cocktail, 30 Marinated Herring, 35
Orange or Grapefruit Juice, 25 double, 40
Tomato or Clam Juice, 25 double, 40

SOUPS
Chicken Broth, 30 cup, 20
Cream of Tomato, 30 cup, 20

STEAKS, CHOPS, ETC.
(Including French Fried Potatoes)
Sirloin Steak (per person), 1.85
Tenderloin Steak (per person), 1.80
Half Broiled Chicken, 1.25 Steak Minute, 1.60
Veal Chop, 1.00 Pork Chop (1), 50 2 Chops, 90
Lamb Chop (1), 50 Grilled Ham Steak, 1.00
Fresh Mushrooms on Toast with Bacon, 75
Roast Prime Rib of Beef, 1.15

FRESH VEGETABLES & POTATOES
New Peas in Butter, 30 New Lima Beans, 35
New String Beans, 30 Cauliflower, 35
New Boiled Potato, 20 Mashed Potatoes, 25
French Fried or Lyonnaise Potatoes, 25

SALAD BOWLS
Chef's Salad, 40 Chiffonade, 40
Chicken, 1.15 Shrimp, 80 Crabmeat, 1.15
Maurice (Julienne of Chicken, Ham,
Lettuce, Tomato, Egg), 70

DESSERTS • ICE CREAM
Assorted Pies, 25 Cake, 25 French Pastry, 20
Rice Pudding, 20 Compote of Fruits, 35
Mince Pie, 30 Pumpkin Pie, 25

Vanilla, Strawberry or Chocolate Ice Cream, 25
Pistachio Ice Cream, 25 Raspberry Sherbet, 25

CHEESE
Liederkranz or Camembert, 30 Roquefort, 30
American or Cream, 25 Switzerland Swiss, 30

BEVERAGES
Coffee, 15 Milk, 15 Tea, 15

Bread and Butter 10¢ per person

ALL RESTAURANT FACILITIES
AT LA GUARDIA FIELD OPERATED
BY HOTEL NEW YORKER, NEW YORK
FRANK L. ANDREWS, PRESIDENT

RUNWAY COCKTAIL
35c
Vermouth, Akvavit,
Lemon Peel

PLANKED STEAK
DINNER $2.50
Tomato Juice Grapefruit Juice
Fruit Cocktail Cherry Juice
Seafood Canape
Soup du Jour
Consomme
★
Celery Radishes Olives
★
Planked Sirloin Steak
with Mushrooms and Fresh
Garden Vegetables
★
Chef's Salad
★
Choice of Dessert
★
Coffee

ON THE PLANES
ALSO, IT'S
NEW YORKER FOOD

America's most discriminating pur-
chasers of everything required for
"top-flight" service to the travel-
ing public are the airlines . . . We
are proud to have been selected for
the duty of preparing in our special
kitchens all meals served aboard
departing Clippers of the Pan
American Airways, Inc., and the
Airliners of American Airlines,
Inc., Canadian Colonial Airways,
Eastern Air Lines, Inc., and
United Air Lines.

Not responsible for personal pro-
perty unless checked in coat room

C. K. DWINELL
Manager, Airport Restaurants

CLUB DINNERS

	TOMATO JUICE	CANAPE MODERNE
AIL		CONSOMME
OUR		

* * *

OF CELERY MIXED OLIVES

* * *

- BRAISED TOP SIRLOIN IN RED WINE SAUCE, 1.00
 LAKE ERIE TROUT WITH LEMON BUTTER, 1.20
OF HALIBUT WITH TOMATOES, AIRPORT, 1.30
DDLE OF SPRING LAMB, MINT JELLY, 1.45
ST VERMONT TURKEY, AMERICAN DRESSING,
 CRANBERRY SAUCE, 1.50
EL OF MILK-FED VEAL, MADEIRA SAUCE, 1.65
 TERRACE CLUB STEAK, 1.85
VEGETABLE DINNER WITH POACHED EGG, 1.00
IME RIBS OF BEEF WITH NATURAL GRAVY, 1.50
—BAKED VIRGINIA HAM AND SLICED TURKEY,
 WALDORF SALAD, 1.65

VEGETABLES AND POTATOES
(Choice of One Vegetable and Potato)

ING BEANS CARROTS AND PEAS
POTATOES CANDIED SWEET POTATOES
 RISSOLE POTATOES

* * *

MIXED GREEN SALAD

* * *

DESSERTS AND ICE CREAM
 LAYER CAKE CARAMEL CUSTARD
HERBET JELL-O FRUIT COMPOTE
RAWBERRY, CHOCOLATE OR PISTACHIO ICE CREAM
DING NEW GREEN APPLE PIE STEWED FRUIT
PASTRY ORANGE SHERBET

* * *

FFEE TEA MILK

to mail souvenir menus to friends, please ask Captain for envelopes.
We pay the postage.

MENU OF THE AVIATION TERRACE RESTAURANT, 1939. In spite of the seemingly low prices, this was the same as dining at one of the better Manhattan restaurants in 1939. Note the menu states that, on all flights out of the airport, the same food was prepared by the Hotel New Yorker. A coffee shop and bar serviced the more casual visitor. (CAM.)

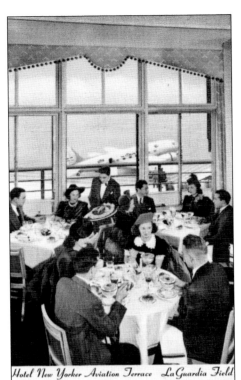

INTERIOR VIEW, AVIATION TERRACE RESTAURANT, 1939. This upscale art deco establishment did a brisk business with a public that regarded a busy airport as a unique form of entertainment. Dining at a fine airport restaurant was also the same as frequenting the best restaurants in Manhattan. It was a place to see and be seen. (CAM.)

Hotel New Yorker Aviation Terrace La Guardia Field

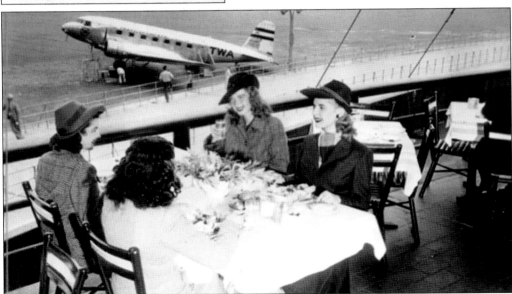

OUTDOOR DINING AT THE AVIATION TERRACE RESTAURANT, 1940. Some well-dressed visitors enjoy lunch with a TWA DC-2 in the background. The restaurants brochure lauded, "As you loll and laugh over a delicious meal, a mammoth spectacle unfolds before you. Out of the sky a silver ship drifts silently to a perfect landing. Giant motors roar into the blue. Famous personages come and go. And from the sparkling Sound, a 'Clipper' takes off for distant lands in a swirling cloud of spray." (CAM.)

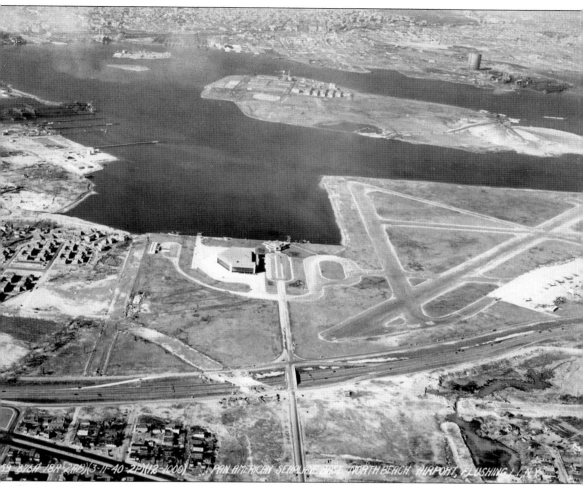

SEAPLANE BASE AT LAGUARDIA FIELD, LOOKING NORTHEAST, 1940. The landplane runways and hangars are to the right; in the center are the Marine Air Terminal and Seaplane Maintenance Hangar. At the time, the planes with the largest capacity and greatest range—thus requiring the longest takeoff run—operated on water. That is why LaGuardia was, and still is, the only commercial airport in the United States originally built to service seaplanes. In the distance can be seen Rikers Island, a prison. (CAM.)

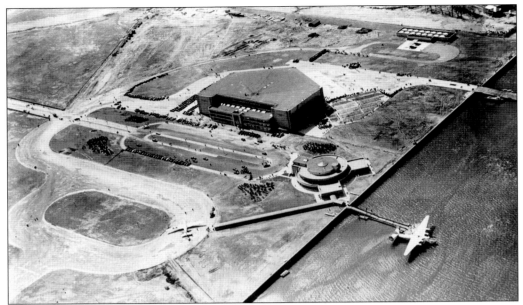

THE MARINE AIR TERMINAL AND MAINTENANCE HANGAR, C. 1940. The Marine Air Terminal at LaGuardia Airport was the first international air gateway to the United States. The simple, round, domed building was modeled on Rome's Pantheon, with light entering through a central skylight. The circular building with passenger flow on one level worked well for the low volume of the daily flying boat passengers. (CAM.)

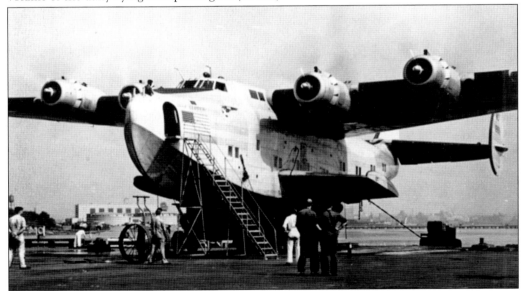

BOEING B-314 BEING RUN-UP ON THE SEAPLANE RAMP, 1940. Next to the Marine Air Terminal was a seaplane ramp where the huge Boeing flying boats could be hauled out of the bay for maintenance. Here mechanics watch a Pan American Airways flying boat have its engines run-up while sitting on the ramp, probably after a maintenance overhaul. Note the Caterpillar tractor behind the plane, which is how the planes were pulled out of the bay and up the ramp. (CAM.)

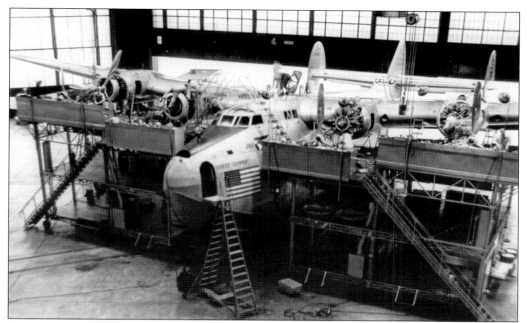

BOEING B-314 UNDERGOING MAINTENANCE, 1940. One of the more impressive technical achievements at LaGuardia Airport was the immense seaplane maintenance hangar. This unique structure had roof trusses radiating from one central pillar near the wide-door side of the structure, leaving the rest entirely open. This allowed up to three flying boats at once to fit inside. (CAM.)

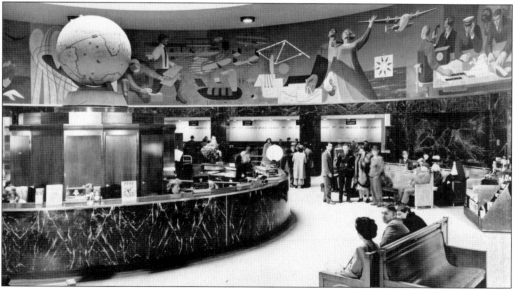

INTERIOR OF THE MARINE AIR TERMINAL, C. 1940. A beautiful art deco building, the LaGuardia Marine Air Terminal is unique among American airport structures. The upper interior contained a 235-foot circular mural painted by James Brooks between 1938 and 1942 as part of the WPA art program. This was the largest and last mural painted as part of this program, and its theme was "man's yearning for flight and its final realization." During the McCarthy era in the 1950s, the mural was painted over, as it was thought to be associated with communism. (CAM.)

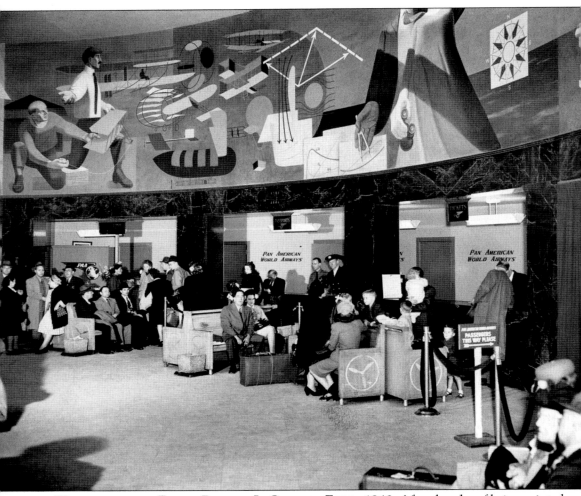

WAITING FOR THE FLYING BOAT AT LAGUARDIA FIELD, 1940. After decades of being painted over and forgotten, Geoffrey Arend, publisher of aviation newspapers, began a campaign to uncover and restore the magnificent murals in the late 1970s. By 1979, Arend personally raised over $75,000 to have the murals restored by professional conservators. They have now been uncovered and returned to their original glory. (PANYNJ.)

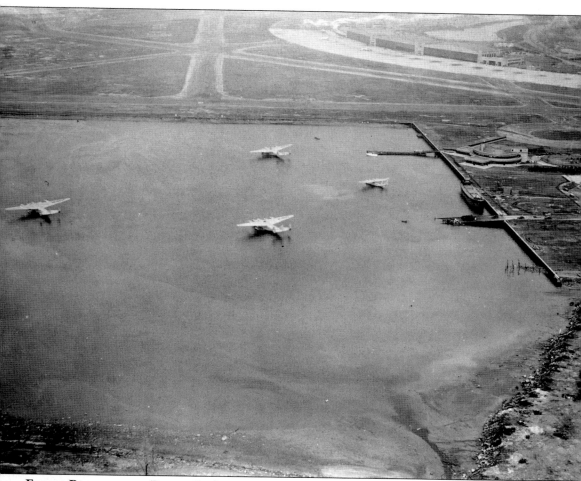

FLYING BOATS IN THE BAY AT LAGUARDIA FIELD, C. 1940. This rare photograph shows three Pan American Airways Boeing B-314 flying boats anchored in Bowery Bay along with a smaller Sikorsky S-42. On the right, a tanker is unloading fuel for the airfield's tank farm. (CAM.)

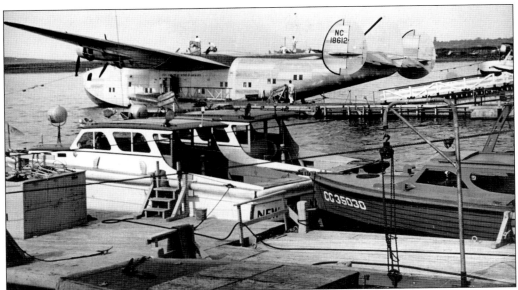

PAN AMERICAN AIRWAYS BOATS AND BOEING B-314 TIED UP, 1940. Pan American Airways kept three boats always at the ready. They were used to haul lines and clear debris out of the bay. One contained a radio to communicate with the Clippers on takeoff and landing. Another contained firefighting gear and a large suction hose to be used to pump out a plane if it was sinking. On dead calm days, the boats ran up and down the bay to try to create just enough chop so that the flying boats could break free of the water's suction on takeoff. (CAM.)

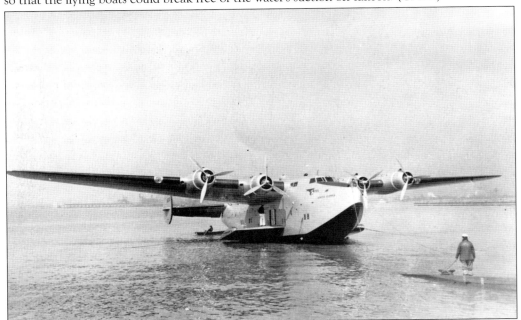

PAN AMERICAN AIRWAYS BOEING B-314 BEING HAULED TO THE DOCK, C. 1939. Boeing's Clipper project began in 1935, with the first one flying in 1938. These flying boats were then the largest civil aircraft in service. A total of 12 were built for Pan American Airways at a cost of $550,000 each. (CAM.)

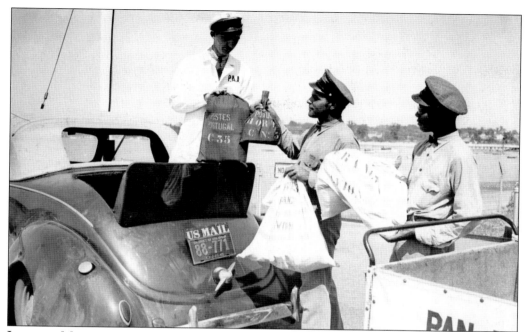

LOADING MAIL ON THE FLYING BOAT, C. 1939. In January 1939, Pan American Airways began transpacific flights with the Boeings, and by the spring, they were spanning the Atlantic Ocean. On the transatlantic flights, refueling stops were made in Newfoundland and Foynes, Ireland. (CAM.)

PASSENGER BOARDING THE FLYING BOAT, LaGUARDIA FIELD, 1940. The Boeing boats could carry 74 passengers for shorter flights to Bermuda or 40 passengers on overnight flights to Europe. In addition, there was a 10-man team consisting of flight crew and stewards. By the end of 1939, Pan American Airways had made 100 successful transatlantic crossings. (CAM.)

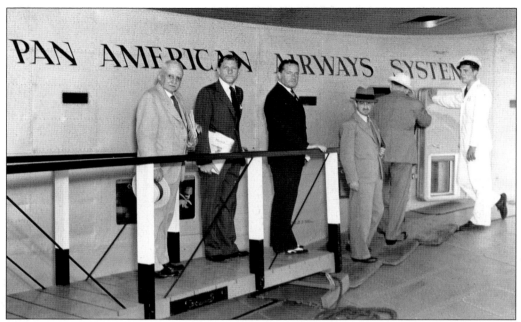

BOARDING THE FLYING BOAT, MARINE AIR TERMINAL, 1940. On the trips to Europe, up to 40 privileged passengers paid $375 for one-way tickets or $675 round trip. This would be about $8,000 today. The second person from the left is Howard Dietz, MGM advertising and publicity mogul. (CAM.)

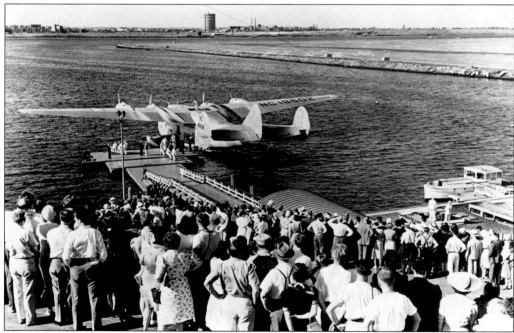

WATCHING A FLYING BOAT DEPART, MARINE AIR TERMINAL, 1940. The Boeing B-314 had a 152-foot wingspan and was powered by four 1,600-horsepower Wright R-2600 engines. It crossed the Atlantic Ocean at a leisurely 188 miles per hour. (PANYNJ.)

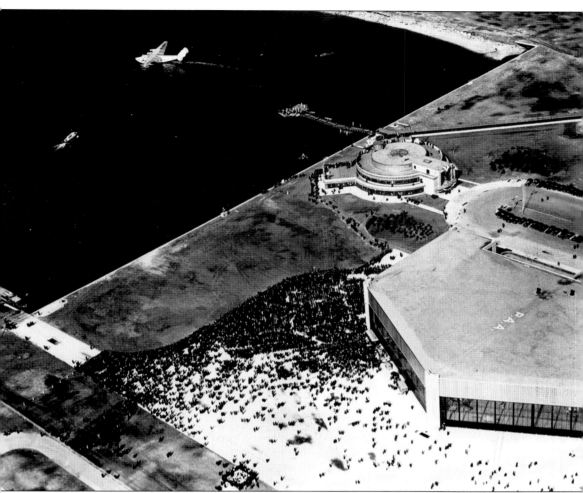

A Pan American Airways Clipper Taxiing Out for Takeoff, 1940. The large crowd is probably to observe the first transatlantic flight out of LaGuardia Airport on March 31, 1940. Clipper departures and arrivals always drew a large crowd; not only was the takeoff a spectacle, but the passenger list was also entirely composed of the rich and famous. (PANYNJ.)

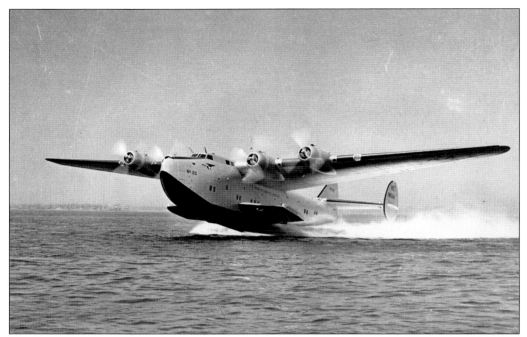

PAN AMERICAN AIRWAYS CLIPPER TAKING OFF, BOWERY BAY, 1940. The golden age of the commercial flying boat was fairly brief at LaGuardia Airport. The Pan American Airways flying boats operated from here between March 1940 and June 1945. (CAM.)

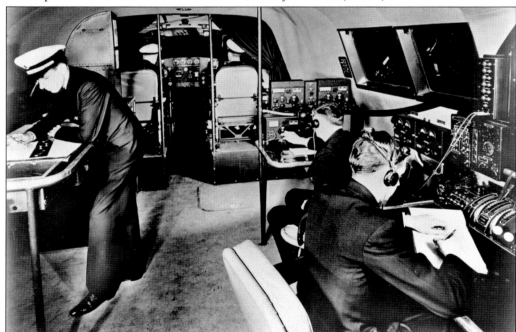

FLIGHT DECK OF A BOEING B-314, C. 1939. The spacious flight deck held a crew of five. From left to right are the navigator, pilot, copilot, radio operator, and flight engineer. The cockpit on the B-314 was referred to as the bridge. A spiral staircase led down to the passenger decks. (CAM.)

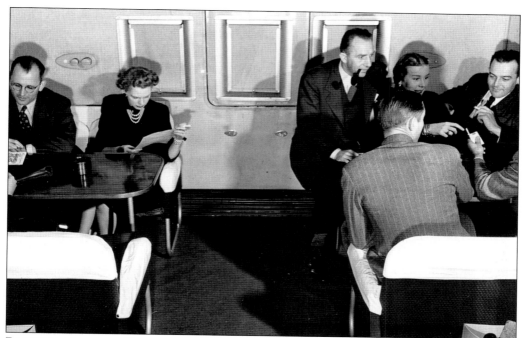

PASSENGER LOUNGE, BOEING B-314, C. 1939. The cozy but comfortable passenger lounge was the social gathering spot on the B-314s. Reading and smoking were encouraged, and bar service was always available. All the passengers were only from the upper class of society. (CAM.)

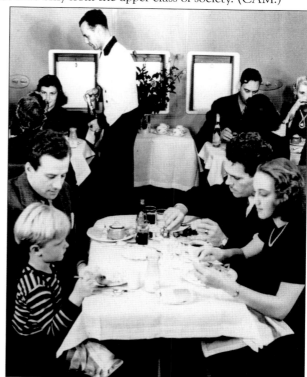

DINING SALON, BOEING B-314, C. 1939. Stewards served gourmet meals prepared in the galley of the flying boat. As if on a luxury liner, the wealthy passengers had come to expect the comforts of private dressing rooms, dining salons, lounges, gourmet meals, and private baths. (CAM.)

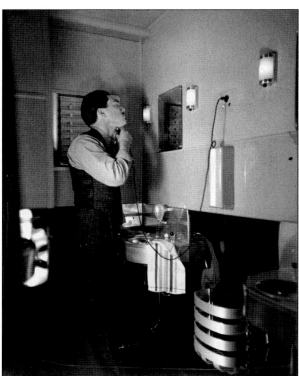

MEN'S RESTROOM, BOEING B-314, C. 1939. Unlike today's claustrophobic airliner bathrooms, the Boeing B-314s had separate men's and women's restrooms, each posh and roomy art deco masterpieces. (CAM.)

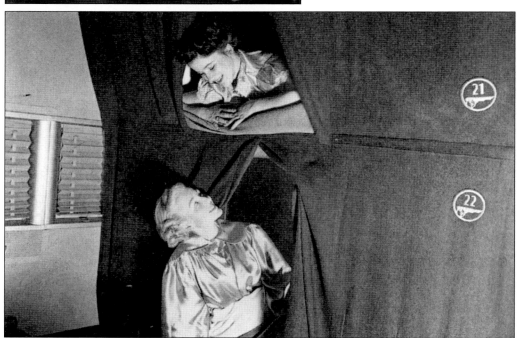

STATEROOM BERTHS, BOEING B-314, C. 1939. The Boeings bedtime berths were wider and longer than those found aboard the finest Pullman railcars. All cabin appointments were designed by Norman Bel Geddes, a world famous industrial designer. (CAM.)

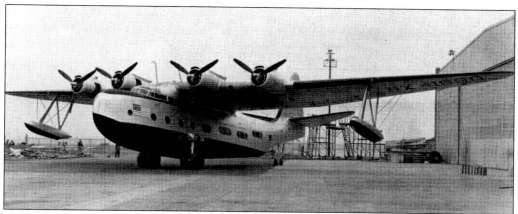

AMERICAN EXPORT AIRLINES VS-44, 1942. Pan American Airways was not the only airline to operate flying boats out of LaGuardia Airport. The steamship company American Export Lines purchased four Vought-Sikorsky VS-44s in 1942 and operated them on a transatlantic service through 1945. Smaller and less palatial than the B-314s, the VS-44s had sleeping accommodations for 16, but with a longer range, they did not have to stop at Newfoundland to refuel. (CAM.)

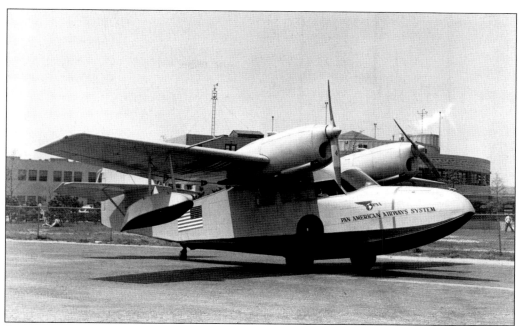

GRUMMAN WIDGEON, OUTSIDE THE MARINE AIR TERMINAL, 1940. Pan American Airways also stored up to five Grumman Widgeons in the enormous Seaplane Maintenance Hangar at LaGuardia Airport. They were mainly used for pilot proficiency, to keep their flight crews current on the intricacies of long-range navigation, and to practice landings in the bay. (CAM.)

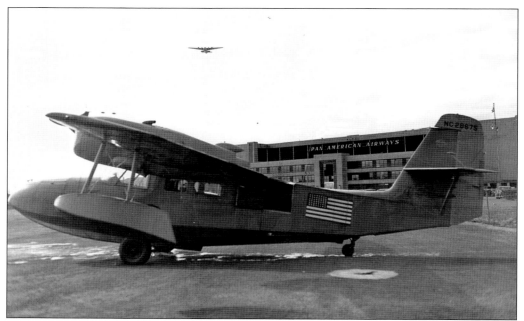

PAN AMERICAN AIRWAYS GRUMMAN WIDGEON, 1940. The large flag on the fuselage indicates the photograph was taken prior to American entry into World War II in 1941 while America was still neutral. Thus these neutrality markings were painted on all civil aircraft that might venture offshore. Note the majestic flying boat soaring overhead. (CAM.)

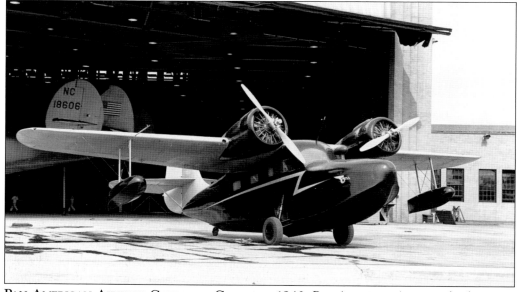

PAN AMERICAN AIRWAYS GRUMMAN GOOSE, C. 1940. Pan American Airways also kept one Grumman Goose at LaGuardia Airport, mainly used as a personnel transport for executives. Pan American also used Gooses as short-haul transports in the Bahamas. Note the Boeing B-314 parked inside the hangar. During World War II, the progress made in long-range landplanes, such as the Douglas DC-4 and Lockheed Constellation, which were cheaper to build and operate, rendered the flying boats obsolete by the end of 1945. (CAM.)

Three

TAKING OFF
1941–1950

ANTIAIRCRAFT GUN, LAGUARDIA FIELD, 1941. Immediately after the Pearl Harbor attack, there was great concern that LaGuardia might be the target of a possible air raid. Thus sentries were posted to guard the aircraft from saboteurs, and several antiaircraft gun batteries were placed on the field. In the background the Landplane Terminal can be seen. (PANYNJ.)

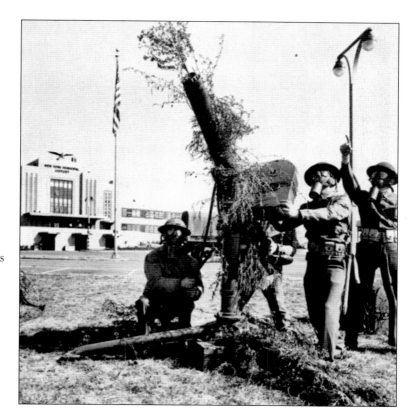

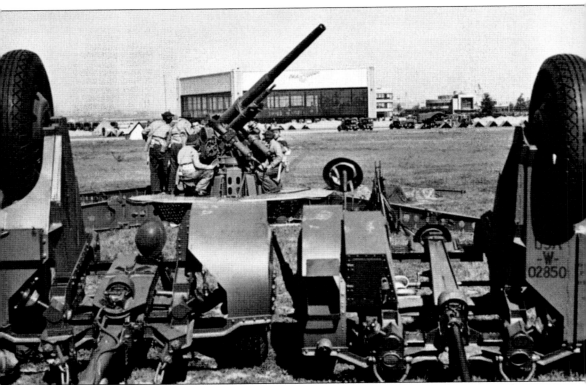

ANTIAIRCRAFT GUN POSITION, LAGUARDIA FIELD, C. 1942. Following the invasion hysterics generated by the Pearl Harbor attack, through the end of 1942, several antiaircraft gun positions were established on the field, and a group of P-40 fighters from nearby Mitchel Field were placed here. In the background the Marine Air Terminal and Seaplane Maintenance Hangar can be seen. (PANYNJ.)

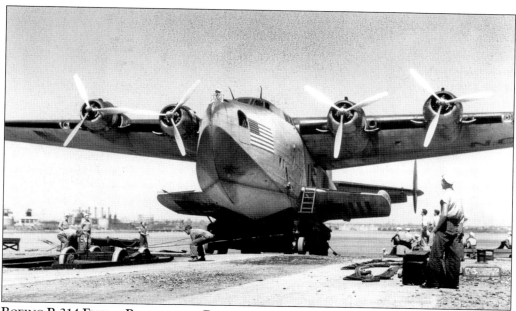

BOEING B-314 FLYING BOAT ON THE RAMP, C. 1942. Following United States entry into World War II, the Pan American Airways Clippers operating out of LaGuardia Airport were given a coat of dark blue camouflage paint over their formerly shining exterior. Virtually all of the passengers were now high-ranking military officers or diplomatic officials. Passenger manifests also became top secret. (CAM.)

TWA MECHANICS AT LAGUARDIA FIELD, 1943. Due to the manpower shortage that set in during the war, for the first time, the airlines accepted a limited number of female mechanics. Immediately after the war, all were excessed. (CAM.)

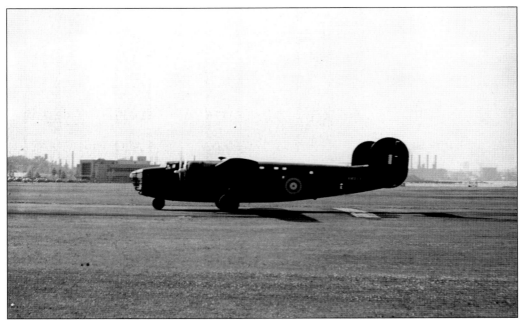

CONSOLIDATED LB-30 BOUND FOR ENGLAND, LAGUARDIA FIELD, 1943. During the war, Consolidated sold a number of LB-30s to England. They were unarmed transport versions of the B-24 bomber. Some were operated by Royal Air Force No. 511 Squadron of the North Atlantic Ferry Service. Thus LaGuardia Airport served as their East Coast base, ferrying cargo and personnel to England via Greenland, during the war. In the background, the Marine Air Terminal can be seen. (CAM.)

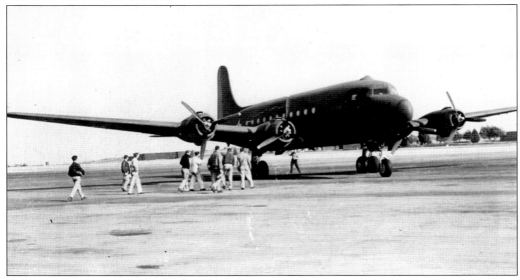

C-54 AT LAGUARDIA FIELD, C. 1944. The DC-4 was developed in the late 1930s as a replacement for the popular DC-3, but before it could enter service, the outbreak of World War II meant that production was channeled to the military as the C-54. Thus during the war, C-54s of the U.S. Army's Air Transport Command were regular visitors to LaGuardia Airport, as they ferried military personnel around the country as well as overseas. (CAM.)

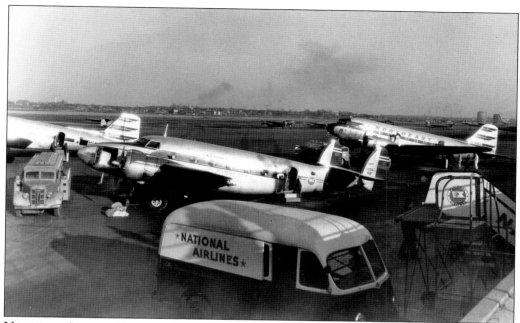

National Airlines Lockheed 18 Lodestar at LaGuardia Field, 1944. The 14-passenger Lockheed 18 was introduced in 1939; however, its performance and payload was inferior to the DC-3. Thus it was mainly used by airlines unable to obtain DC-3s. Florida-based National Airlines began service from Miami to LaGuardia beginning in 1944. (CAM.)

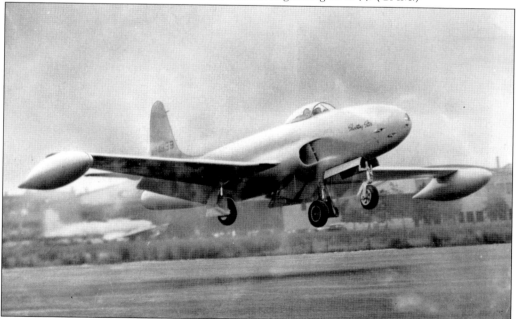

The First Jet to Land at LaGuardia Field, 1945. The jet age, temporarily, arrived at LaGuardia Airport on August 1, 1945, when a U.S. Army P-80 Shooting Star flew in from Wright Field in Dayton, Ohio. The plane made the 589-mile flight in the record-breaking time of one hour and two minutes. The plane was flown by Col. William Council. (CAM.)

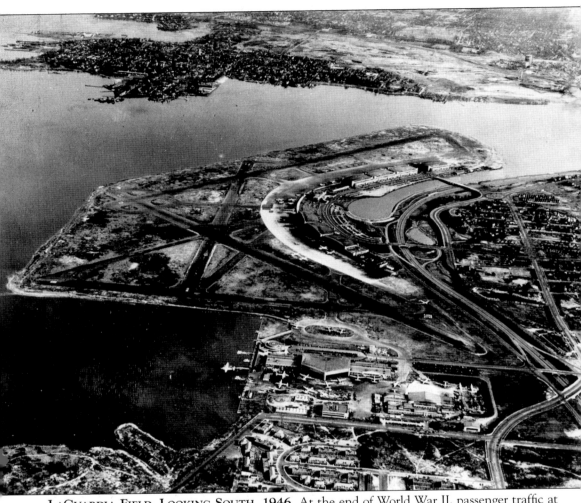

LaGuardia Field, Looking South, 1946. At the end of World War II, passenger traffic at LaGuardia Airport began to increase dramatically. Also in 1946, air-minded Fiorello LaGuardia was no longer mayor of New York, and the early years of LaGuardia Airport came to a close. Note one remaining flying boat anchored at the Marine Air Terminal, while the Seaplane Maintenance Hangar has now been given over to landplane repair. (PANYNJ.)

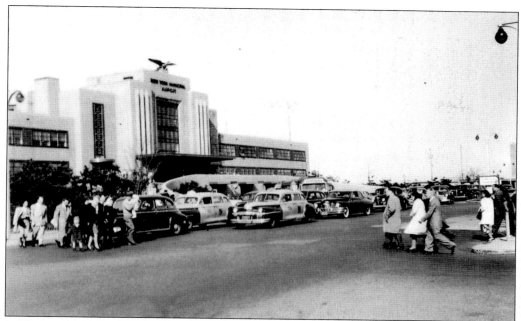

LaGuardia Field, Landplane Terminal, c. 1946. By the late 1940s, LaGuardia Airport was beginning to experience air traffic never before seen by any commercial airport. In 1948, the 19 scheduled airlines now operating at LaGuardia handled 2.7 million passengers, and the field averaged 400 flights a day. (Sam Koppel.)

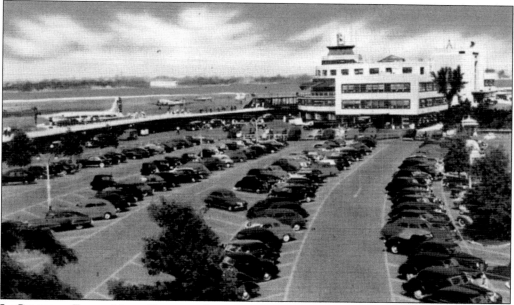

LaGuardia Field, Main Parking Lot and Terminal, c. 1948. After World War II, the new mayor of New York, Vincent Impelliterri, decided that the city should no longer be in the airport business. Thus in 1947, the Port of New York Authority, now the Port Authority of New York and New Jersey, leased LaGuardia Airport and the new city airport under development on the south shore of Queens, Idlewild Field, for 50 years. (CAM.)

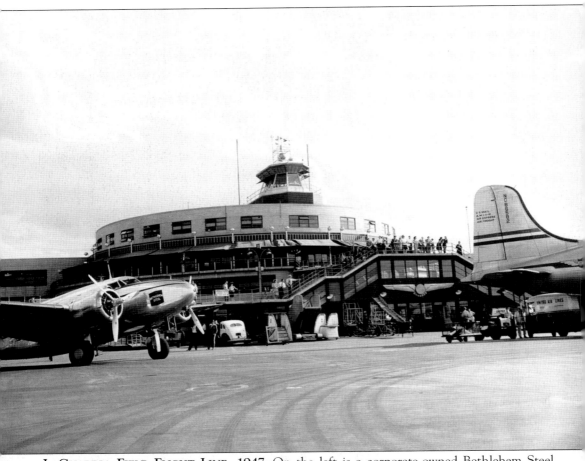

LaGuardia Field Flight Line, 1947. On the left is a corporate-owned Bethlehem Steel Lockheed Lodestar, and the tail on the right belongs to a United Air Lines DC-4. Spectators on the Skywalk watch the exciting airport action. A public address system kept them informed of aircraft movements. (PANYNJ.)

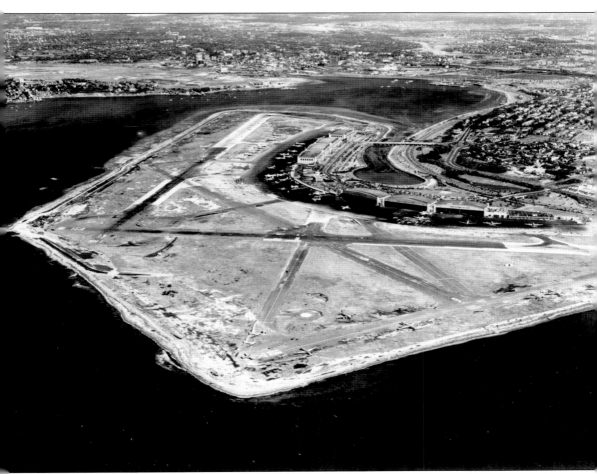

LaGuardia Field, Looking South, 1949. The postwar era was a boom time for commercial aviation. People were ready to fly, and technology had improved to the point that airplanes were safer and bigger, so the cost of flying began to come down. On the field, the boat basin is still there, and aircraft are now parked around the perimeter to keep the crowded ramp clear for operations. (PANYNJ.)

LaGuardia Tower, 1947. At this point, LaGuardia was the world's busiest airport. New York's other new airport, Idlewild Field, now known as John F. Kennedy International Airport (JFK), had not yet opened, so LaGuardia was America's international air gateway complete with its own customs and immigration service. In the distance, a DC-4 as well as several Lockheed Lodestars are parked. (PANYNJ.)

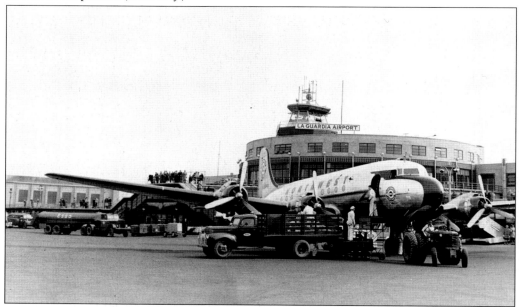

Northwest Airlines DC-4 Loading Baggage, 1948. Minneapolis-based Northwest Airlines was founded in 1926, and by the late 1930s, it flew the northern transcontinental route from New York to Seattle. The DC-4 first flew in 1938, and in the years immediately after World War II, it was the most popular type of American airliner. Most of the DC-4s in service were converted from former military C-54s. (PANYNJ.)

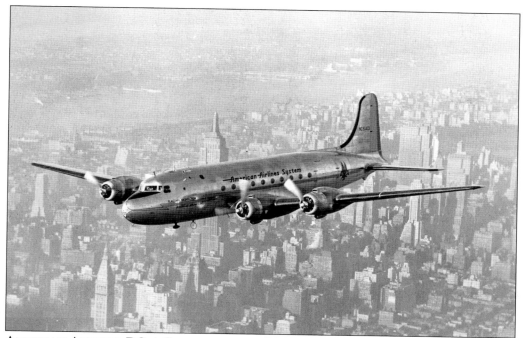

AMERICAN AIRLINES DC-4 OUTBOUND OVER MANHATTAN, C. 1948. The DC-4 was a four engine long-range airliner intended to replace the DC-3. It seated 52 passengers with a fuselage of unusually wide cross section for its day, and it cruised at 227 miles per hour. (CAM.)

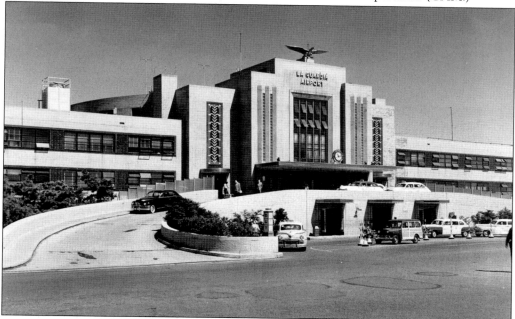

LaGUARDIA AIRPORT CENTRAL TERMINAL, C. 1952. Formerly reading, "New York Municipal Airport," over the terminal entrance, in 1952, the field's name was simply changed to LaGuardia Airport. Although the building is long gone, the magnificent stainless steel eagle still resides atop the former Seaplane Maintenance Hangar next to the Marine Air Terminal. (PANYNJ.)

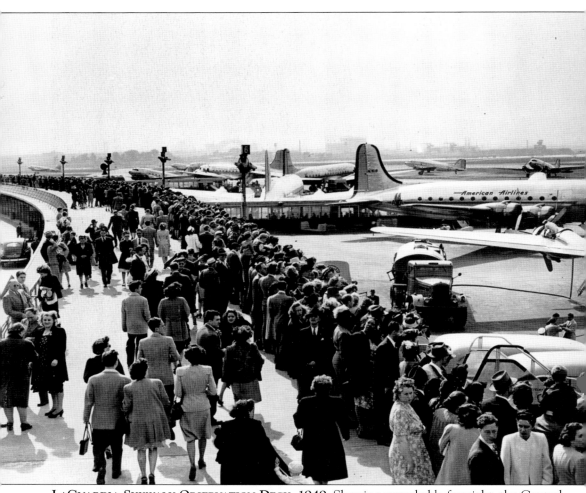

LaGuardia Skywalk Observation Deck, 1949. Showing remarkable foresight, the Central Terminal at LaGuardia Airport was designed with a unique rooftop promenade. Planned to hold 5,000 spectators, on nice weekends as many as 25,000 people visited the airport. This was an era when airports were still tourist attractions, and people picking up travelers stood on the roof and waved to them as they got off the plane. (CAM.)

AMERICAN AIRLINES DC-6 INBOUND OVER NEW YORK HARBOR, 1947. The DC-6 was a piston-engined airliner built by the Douglas Aircraft Company from 1946 to 1959. Originally intended as a military transport during World War II, it was reworked after the war to compete with the Lockheed Constellation in the long-range transport market. (CAM.)

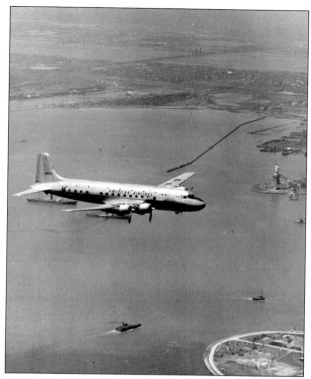

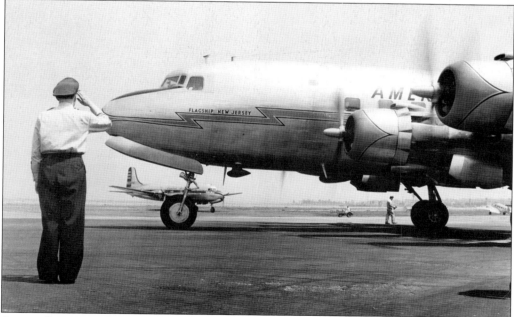

AGENT SALUTING CAPTAIN OF AN AMERICAN AIRLINES DC-6, 1948. The DC-6 was regarded by many to be the ultimate piston-engined airliner from the standpoint of ruggedness, reliability, economical operation, and handling qualities. More than 700 were built, and many still fly today. The gate agent has just cleared the plane for takeoff, and he salutes the pilot. (CAM.)

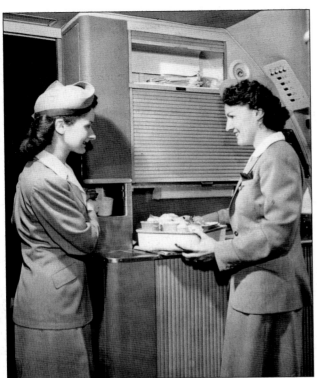

STEWARDESSES PREPARING MEALS ON UNITED AIR LINES DC-6, c. 1950. The DC-6 carried 54 passengers in a sleeper configuration and up to 100 for shorter flights. At the time, all passengers still flew in first class. (CAM.)

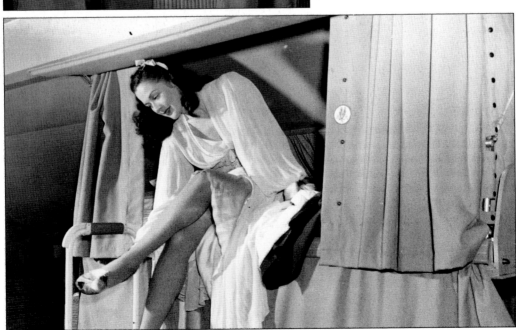

SLEEPING BERTHS ON AN AMERICAN AIRLINES DC-6, c. 1949. The DC-6 was the first airplane to inaugurate tourist-class transatlantic flights by Pan American Airways in 1952. They crossed the ocean at the then-remarkable speed of 315 miles per hour. Sleeping berths, however, were only for first-class passengers. (CAM.)

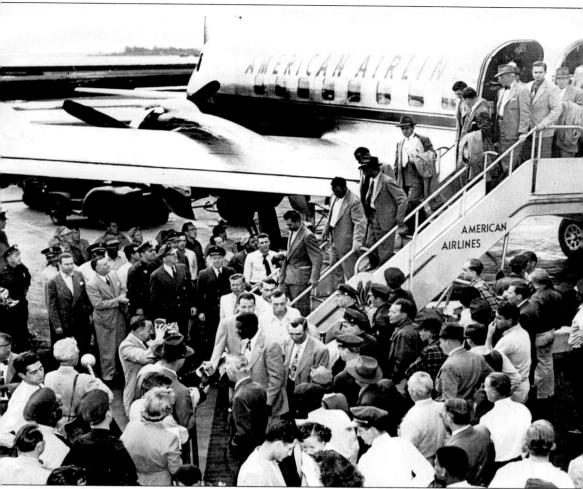

Brooklyn Dodgers Disembarking DC-6, 1948. In the years before sports teams owned their own airplanes, airliners were chartered for the season. Here the Brooklyn Dodgers are returning to LaGuardia Airport aboard an American Airlines DC-6. Jackie Robinson can be seen at the foot of the air stairs. (PANYNJ.)

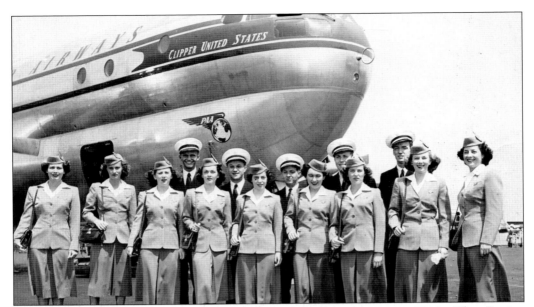

Boeing Stratocruiser and Crew at LaGuardia Airport, 1949. The Boeing 377 Stratocruiser first flew in 1947, and despite serious design flaws and a marginal service record, the Stratocruiser was one of the great postwar airliners. Because they were extremely complex and expensive, only 56 were built. This photograph was probably a Pan American Airways publicity shot taken at LaGuardia Airport to show off the new airliner. The airplane was pronounced too heavy for LaGuardia's runways, so Pan American operated all Stratocruiser flights out of the other New York airport, the newly built Idlewild Field. (CAM.)

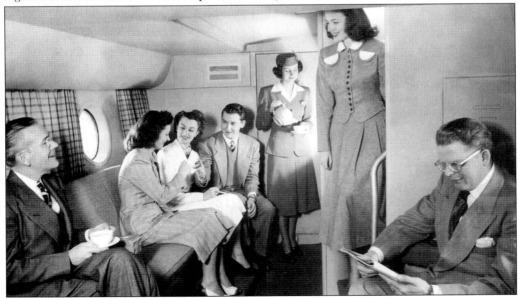

Stratocruiser Lower Lounge, c. 1950. The first plane to have a double-decker seating arrangement, the Stratocruisers Lower Deck Lounge with its spiral staircase inspired the later one on the upper deck of the Boeing 747. Stratocruisers remained in mainline service until 1960 when they were rendered obsolete by the Boeing 707 Jetliner. (CAM.)

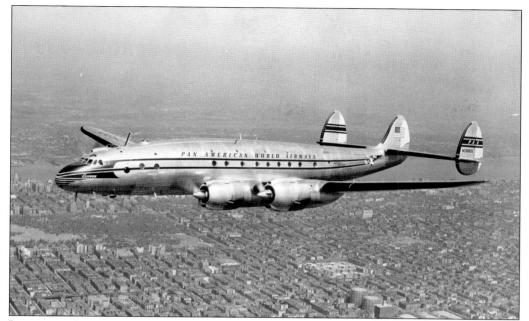

LOCKHEED L-049 CONSTELLATION OVER NEW YORK, 1946. Affectionately known as the "Connie," the L-049 was a hugely successful four engine propeller-driven airliner built by Lockheed between 1943 and 1958. A total of 856 were produced in four models, all distinguished by their distinctive triple-tail and graceful dolphin-shaped fuselage. (CAM.)

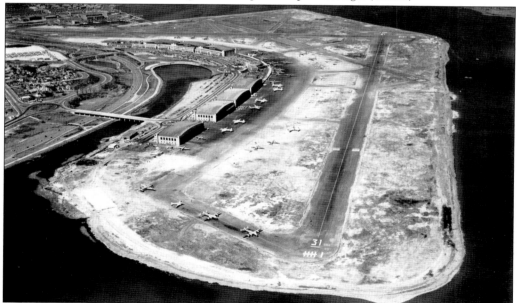

LaGUARDIA FIELD, LOOKING NORTHWEST, 1948. This was LaGuardia Airport at the height of the Constellation years. Designed to make nonstop transcontinental and transatlantic flights, the Constellation was even given its distinctive triple vertical tail instead of having one large one in order to fit into LaGuardia's existing hangars. Prior to the opening of nearby Idlewild Airport, Constellations dominated operations at LaGuardia. (PANYNJ.)

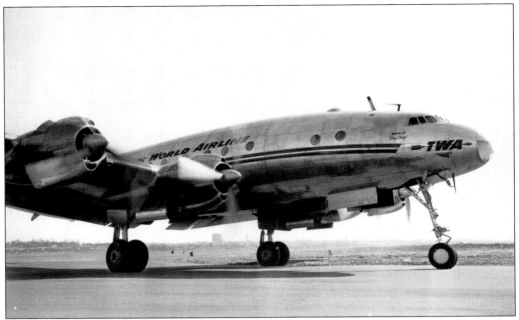

TWA Constellation Taxiing to the Gate at LaGuardia, 1946. On February 3, 1946, This Constellation set a new transcontinental speed record, flying from Burbank, California, to New York, with 55 passengers in 7 hours and 27 minutes. The first operators of Constellations were TWA and Pan American Airways. (CAM.)

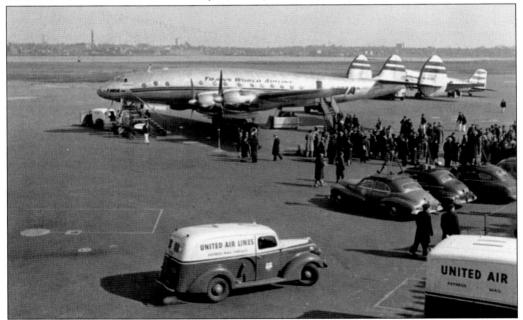

TWA Constellation Preparing to Depart for Paris, 1946. Just two days later, on February 5, 1946, TWA opened postwar intercontinental (landplane) service when this Constellation departed LaGuardia for Paris. Carrying 36 passengers, plus cargo, the flight took nearly 20 hours including refueling stops in Gander and Shannon. (CAM.)

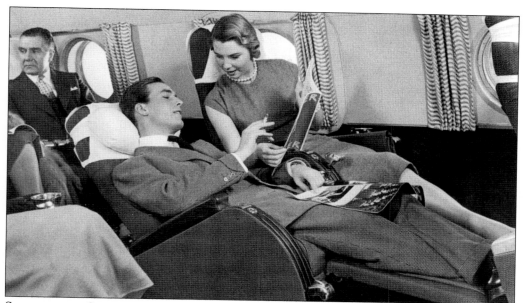

SLUMBERETTE SEATS ABOARD **TWA** CONSTELLATION, C. **1947.** As the first large pressurized airliner in widespread use, the Constellation helped to usher in affordable and comfortable air travel for the masses. In order to fit more people on board, passengers no longer had their own berths. (CAM.)

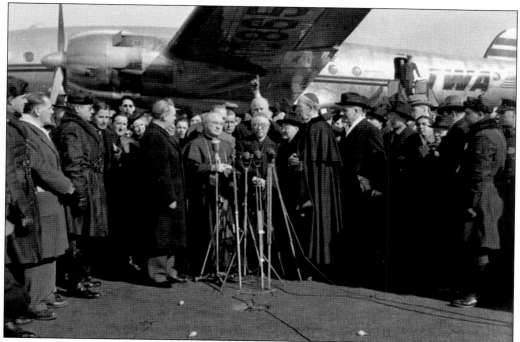

POPE PIUS XII ARRIVING AT LAGUARDIA FIELD, **1946.** As America's aerial gateway (until mid-1948), LaGuardia Airport saw the arrival of many dignitaries to the country. Here Pope Pius XII, to right of center, has arrived at LaGuardia in February 1946 aboard a TWA Constellation. Francis Spellman (speaking), archbishop of New York, was about to be elevated to cardinal. (CAM.)

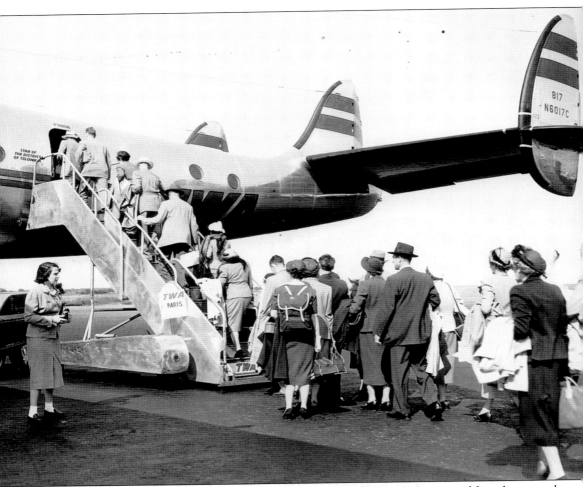

TWA Constellation Departing for Paris, c. 1947. With a flight crew of five plus several stewardesses, the all–first class Constellations normally carried 62 passengers on transatlantic crossings. The advent of jetliners in 1959 rendered the beautiful piston-engined Constellations obsolete. The first routes lost to jets were the transatlantic ones, but Constellations remained in domestic service until 1967. (CAM.)

Four

ENTERING THE JET AGE
1951–1965

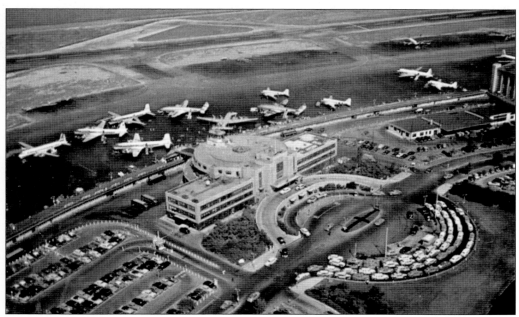

LaGuardia Airport, c. 1955. The Central Terminal, taxi stand, and busy flight line are all evident. By 1957, LaGuardia Airport handled 5,616,000 passengers and had 245,000 aircraft movements. Clearly too small and congested for the amount of traffic it was now handling, plans for its redevelopment were already underway. (CAM.)

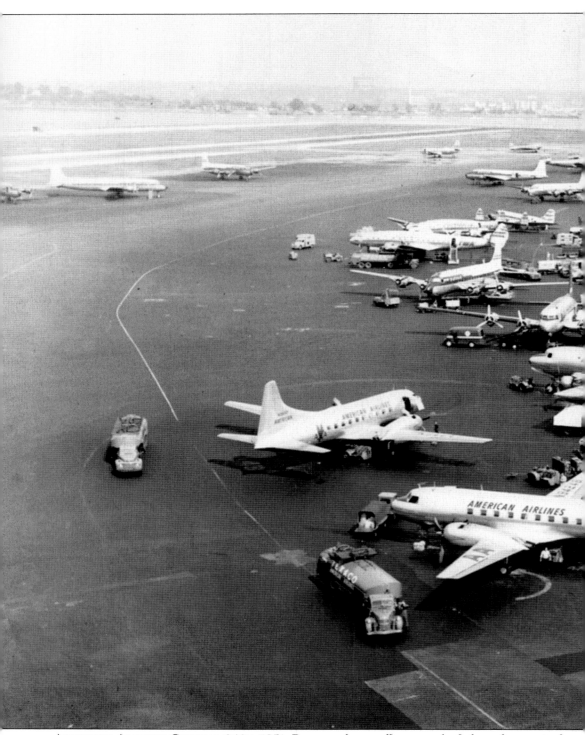

AMERICAN AIRLINES CONVAIR 240S, 1951. By now, a long walkway was built from the terminal to get travelers closer to their aircraft without going outside. The Convair 240 was a 40-seat airliner

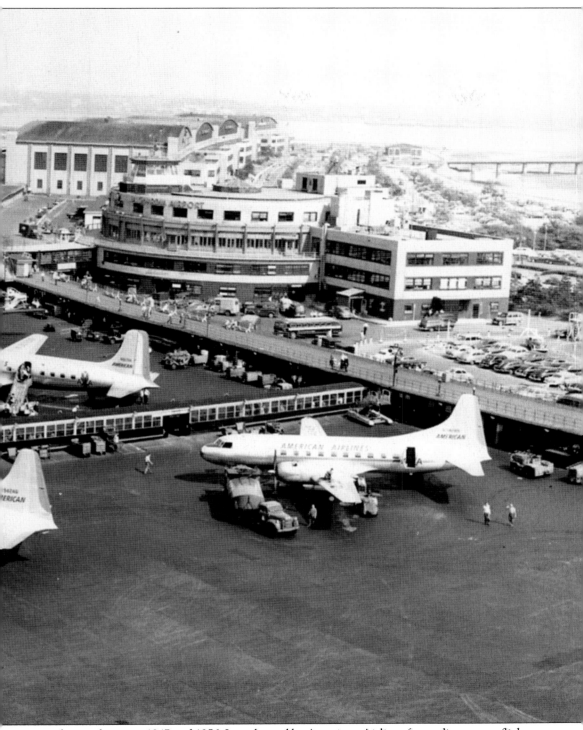

in production between 1947 and 1956. Largely used by American Airlines for medium-range flights, they were a common sight at LaGuardia Airport in the late 1940s and early 1950s. (PANYNJ.)

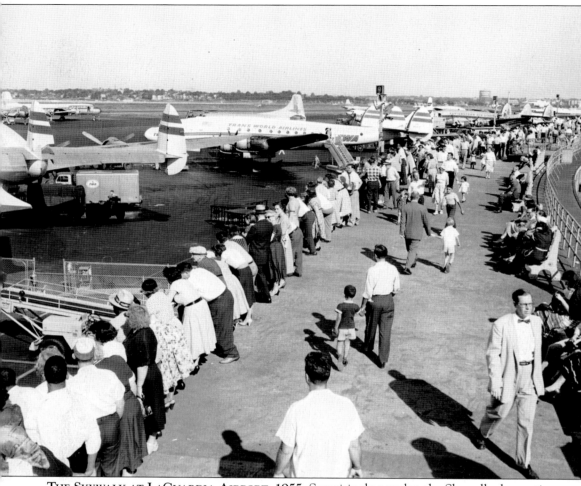

THE SKYWALK AT LAGUARDIA AIRPORT, 1955. Surprisingly popular, the Skywalk observation deck at LaGuardia Airport was a favored New York family destination on sunny weekends. For a dime, people could see the latest airliners up close and even wave to boarding passengers. No one today would ever think of the airport as a fun place to go. (PANYNJ.)

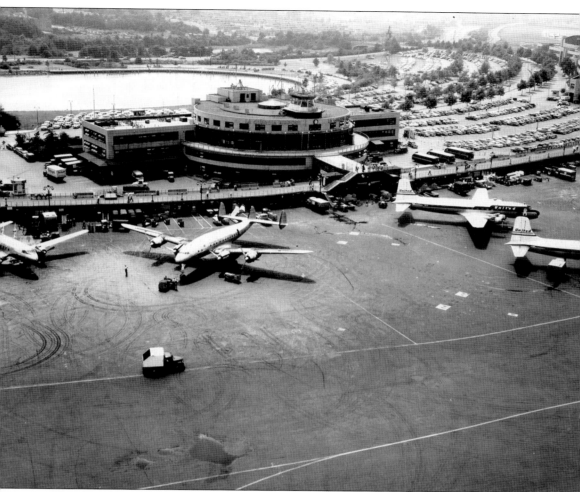

THE FLIGHT LINE AT LAGUARDIA AIRPORT, 1951. Even with all the international flights shifting over to Idlewild Airport, passenger volume continued to grow at unbelievable rates at LaGuardia Airport in the 1950s. Pressure on the parking lot, seen here filled to capacity, was relieved in the mid-1950s when the boat basin and channel were filled in for additional parking. (PANYNJ.)

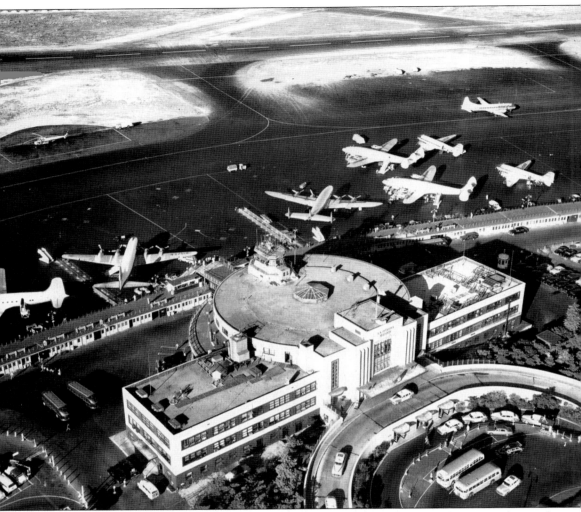

PUBLIC SIDE OF THE CENTRAL TERMINAL, 1953. The location of the control tower and central skylight are clearly visible. The flight line holds DC-3s, DC-6s, and Constellations. Note the helipad in the upper left. In the 1950s, New York airways helicopters carried passengers and cargo between Manhattan, LaGuardia, Newark, and Idlewild Airports. (PANYNJ.)

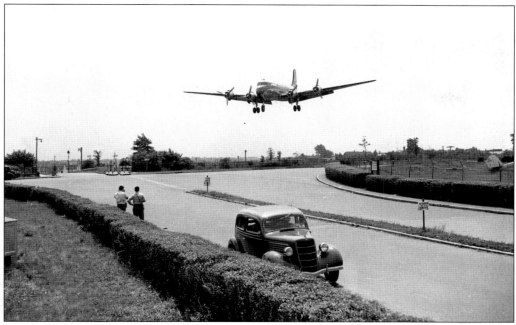

LaGuardia Airport Final Approach, c. 1952. Not only was airplane watching popular from within the airport, but people could also watch from one of several locations just outside the airport perimeter for a really good view. Here a United Air Lines DC-4 gets its photograph taken just before touchdown on runway four. (PANYNJ.)

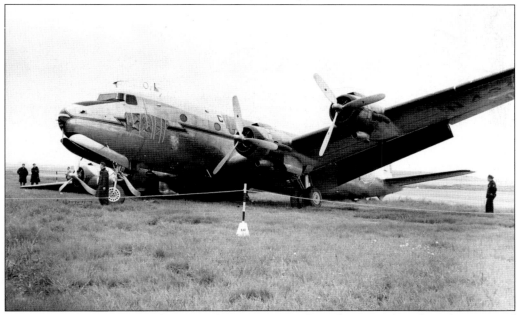

Landing Accident at LaGuardia Airport, 1951. Over the years, there have been several accidents at LaGuardia Airport, although none recently. Here the landing gear collapsed on a Colonial Airlines DC-4 shortly after touchdown. None of the 13 passengers aboard were injured. Note how Colonial quickly covered over its name in an attempt to avoid bad publicity. (CAM.)

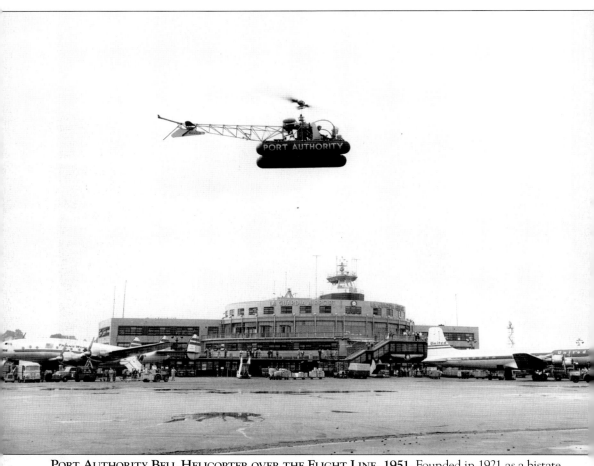

PORT AUTHORITY BELL HELICOPTER OVER THE FLIGHT LINE, 1951. Founded in 1921 as a bistate port district, the Port Authority of New York and New Jersey runs much of the regional transportation infrastructure such as bridges, tunnels, airports, and seaports. The Port Authority of New York and New Jersey first signed a 50-year lease to operate LaGuardia Airport in May 1947. The airport then needed money for expensive upgrades and the city just did not have it. (PANYNJ.)

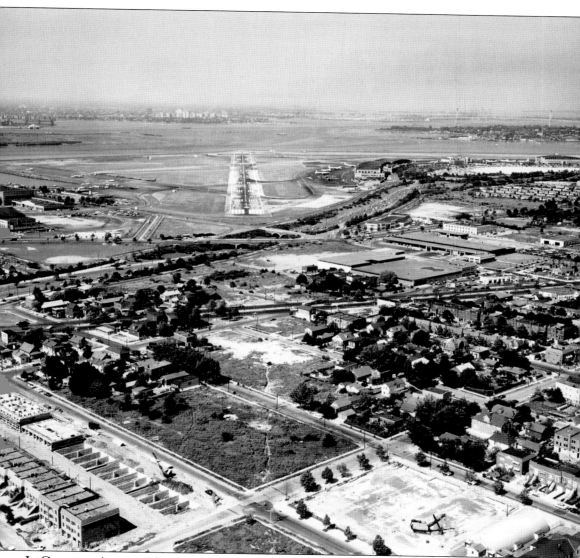

LAGUARDIA AIRPORT APPROACH, 1959. Here is a pilot's-eye view of the approach to runway four, passing over Jackson Heights in Queens. The short length of LaGuardia Airport's original runways is evident. (PANYNJ.)

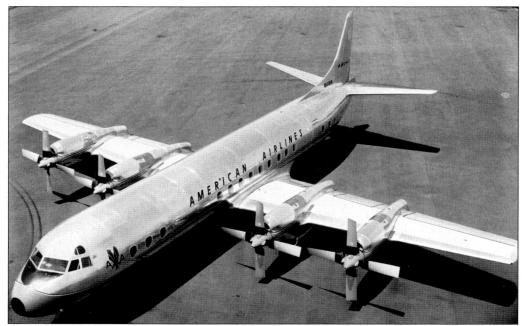

LOCKHEED ELECTRA AT LAGUARDIA AIRPORT, C. 1960. Operations at LaGuardia Airport were dominated by the Lockheed Electra in the 1960s. First flown in 1957, it was the first turboprop airliner built in the United States. Its performance was slightly inferior to jets, but it had a lower operating cost. American Airlines and Eastern Air Lines bought most of the 170 produced. (CAM.)

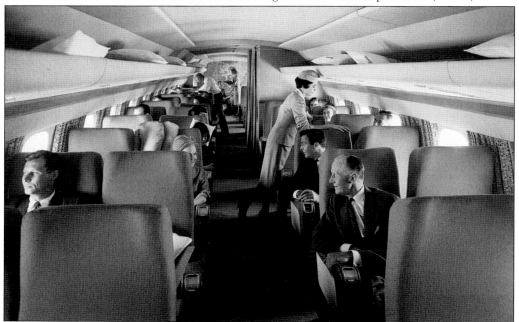

LOCKHEED ELECTRA INTERIOR, C. 1960. The Electra carried between 66 and 88 passengers, depending on configuration, cruising at 405 miles per hour. They remained in service on domestic routes into the mid-1970s. (CAM.)

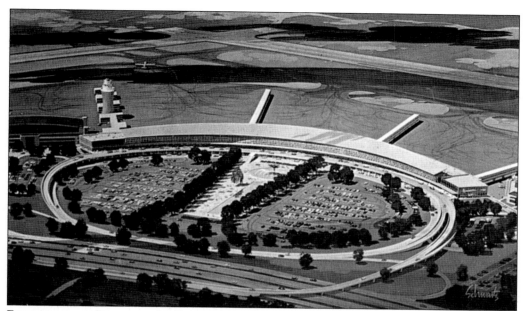

RENDERING OF PROPOSED LAGUARDIA AIRPORT RENOVATIONS, 1961. By the late 1950s, it was obvious that the 1939 New York Municipal Airport was now totally inadequate to handle the passenger volume and aircraft movements that LaGuardia Airport was now experiencing. Thus plans were made to demolish the beautiful 1939 art deco Central Terminal, control tower, gate area, and Skywalk. (CAM.)

CONSTRUCTION OF THE NEW CENTRAL TERMINAL, 1961. The new, four-story glass-and-steel Central Terminal, still in use today, is seven times larger than the original terminal with two three-story wings leading to the gates. Built at a cost of $36 million, the one feature retained was the concept of separating arriving and departing passengers on different levels. (PANYNJ.)

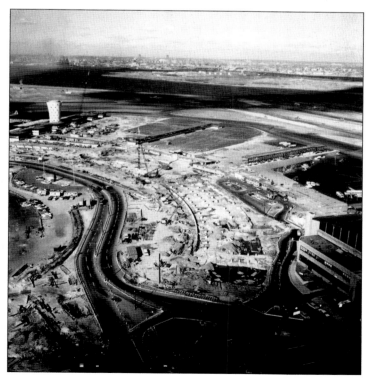

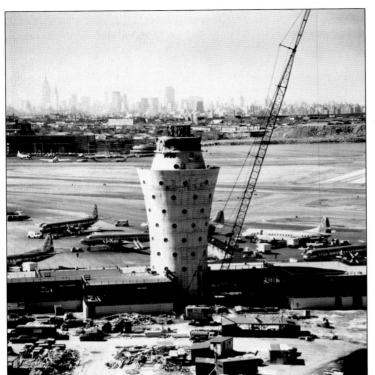

NEW CONTROL TOWER NEARING COMPLETION, 1962. LaGuardia Airport's new tower at the western end of the Central Terminal is 150 feet high and was built at a cost of $15 million. It is in the center of the airport with the best possible view of runways and taxiways. In the background are American Airlines DC-6s, a Lockheed Electra, and the Manhattan skyline. (PANYNJ.)

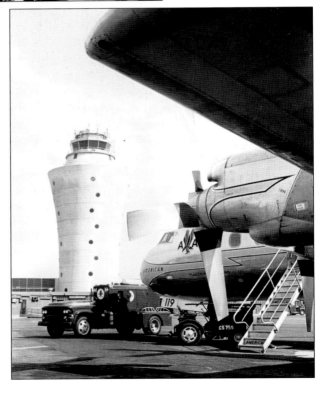

LaGUARDIA TOWER AND LOCKHEED ELECTRA, 1964. The unique control tower at LaGuardia Airport, one of the few ever built with some aesthetic consideration, has been the symbol of the airport for decades. The structure, designed in the shape of a flared vase or urn, has 12 working levels. (PANYNJ.)

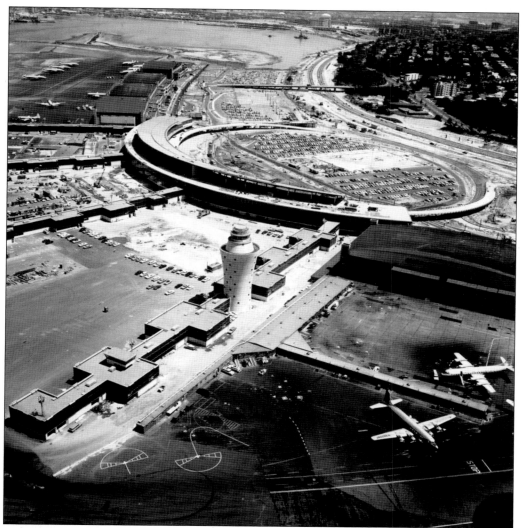

LaGuardia Airport, Looking South, 1963. The new Central Terminal of 650,000 square feet was built at a cost of $36 million. The new facility was dedicated on April 16, 1964, the 25th anniversary of the airport. At the time, the Queens Chamber of Commerce lauded the Port Authority of New York and New Jersey for making Queens "the undisputed airline capitol of the world." Note the long piers extending from the Central Terminal now bringing passengers closer to their aircraft. There were, as yet, no Jetways, so passengers still had to take a short walk from the gate to their plane. (PANYNJ.)

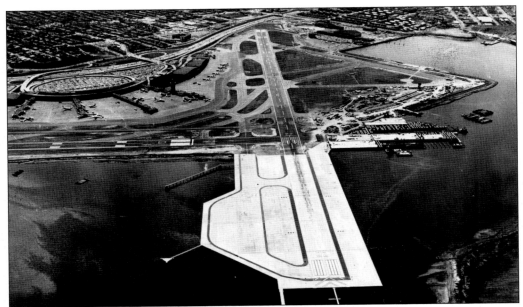

LaGuardia Runway Extensions, 1964. In order to handle jet aircraft, LaGuardia Airport's two runways were given 2,000-foot extensions, bringing them up to 7,000 feet long. Built on steel piers in the Riker's Island Channel, similar extensions had to be built to adjoining taxiways. The amount of steel holding up LaGuardia's runways, however, has made the use of a compass on the airport impossible. (PANYNJ.)

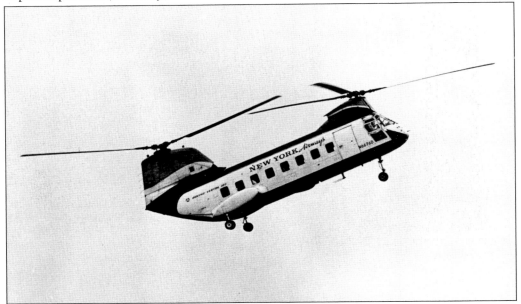

New York Airways Helicopter Landing, c. 1965. Through the 1960s and into the 1970s, New York Airways operated helicopters between the Wall Street Heliport, LaGuardia Airport, and JFK Airport. Operating between 1949 and 1979, New York Airways was the first scheduled helicopter carrier in the United States. Their 25-passenger Boeing Vertol 107 helicopters whisked wealthy passengers from Manhattan to LaGuardia Airport in seven minutes. (CAM.)

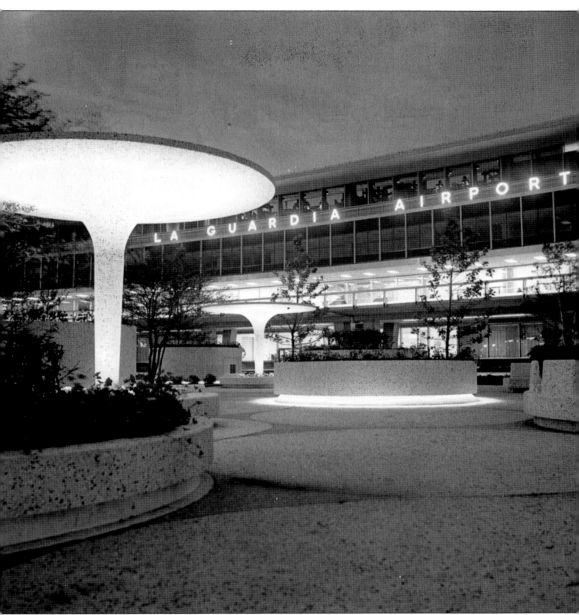

FIORELLO PARK AT THE CENTRAL TERMINAL, 1964. The new Central Terminal at LaGuardia Airport was six blocks long, four stories tall, and had four concourses with 38 aircraft gates. Seen in front, nicely landscaped Fiorello Park, however, has since been replaced by a parking garage. (PANYNJ.)

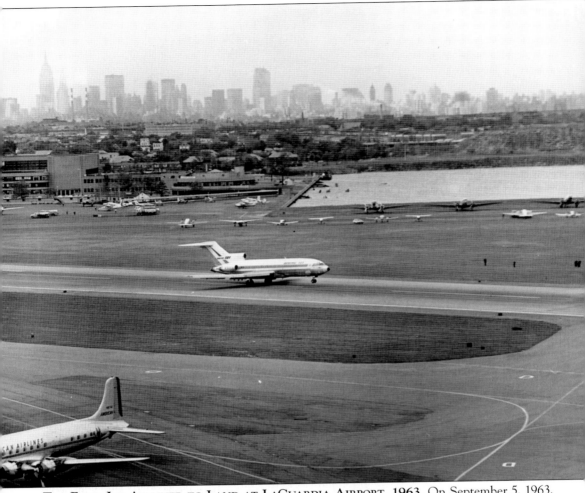

THE FIRST JET AIRLINER TO LAND AT LAGUARDIA AIRPORT, 1963. On September 5, 1963, a Boeing 727 made a survey flight to LaGuardia Airport, thus beginning the airport's jet age. The 727 was the first three-engine trijet introduced into commercial service, and it was the best-selling airliner in the world during the first 30 years of jet-transport service. In production between the early 1960s and 1984, a total of 1,831 were delivered. Note the vintage DC-6 in the foreground and the now-antique DC-3s in the rear. Media and airport people are also on the field standing near the runway. (PANYNJ.)

Five

LaGuardia in the Modern Era
1966–

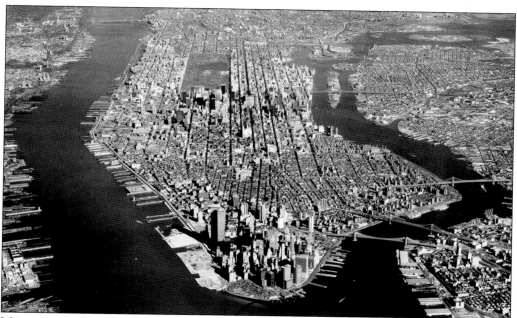

MANHATTAN ISLAND, LOOKING NORTH, 1975. The runways of LaGuardia Airport are just visible in the upper-right corner. Due to its proximity to Manhattan, LaGuardia remains the most popular of the three New York airports for local residents. In an effort to combat overcrowding, in 1984, the Port Authority of New York and New Jersey instituted a perimeter rule banning flights to or from LaGuardia to cities more than 1,500 miles away. (CAM.)

FIORELLO PARK, 1966. In an attempt to keep some semblance of aesthetics at the redeveloped airport, a small, landscaped park was built with an illuminated fountain between the parking lot and the new Central Terminal. The park lasted into the late 1970s, when it was demolished for an expanded roadway system and garage. (CAM.)

LAGUARDIA AIRPORT CENTRAL TERMINAL, C. 1965. This photograph clearly shows the bi-level roadway that serves the terminal. The Grand Central Parkway overpass, at lower right, provided a new entrance to the airport. Departing passengers enter on the second floor from the upper roadway, and arriving passengers pass through arcades and descend by ramp to the first floor to baggage claim and ground transportation. (CAM.)

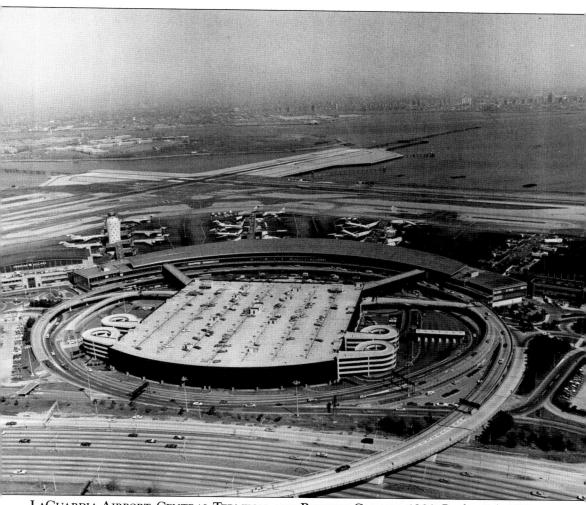

LaGuardia Airport, Central Terminal and Parking Garage, 1980. By the early 1970s, with LaGuardia's continued growth, it became painfully clear that major additional parking would be needed. Thus this huge new parking garage, completed in 1976 at a cost of $40 million, was added. The five-level structure can accommodate almost 3,000 cars and is accessible to the Central Terminal via elevated walkways. (PANYNJ.)

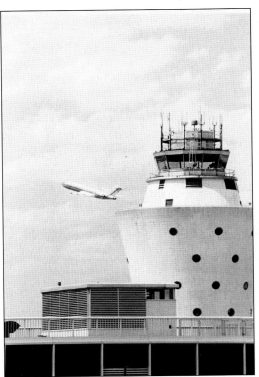

LaGuardia Tower and Boeing 727, 1985. In the 1970s and 1980s, Boeing 727s were the most common aircraft at LaGuardia Airport. The 727 became the best-selling airliner in history when orders passed the 1,000 mark in 1972. By the time production ended in 1984, 1,832 were built. The 727 was clearly one of the most significant airplanes in the development of the world's jet-transportation system. (PANYNJ.)

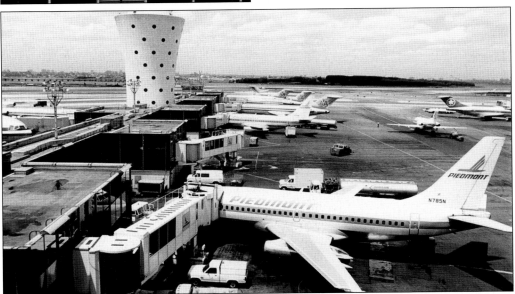

Piedmont Airlines Boeing 737s at the Gate, 1985. The Boeing 737 is a medium-range narrow-body jet airliner. First entering service in 1968, it has become the most-produced commercial passenger jet in the world. Boeing has continuously manufactured it since 1967, with over 7,000 ordered to date. Piedmont Airlines was a North Carolina–based carrier founded in 1948. Serving primarily the mid-Atlantic states, it was purchased and integrated into US Air in 1989. (PANYNJ.)

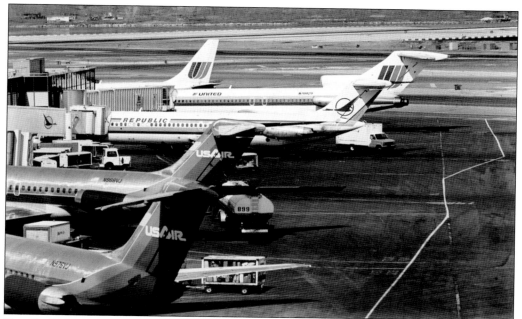

THE LAGUARDIA FLIGHT LINE, 1985. From the mid-1980s to today, LaGuardia Airport has been operating at peak capacity with rarely an open gate. It is the busiest airport in the country without any flights to Europe. Here are two US Air DC-9s, a Republic Airlines DC-9, and United Airlines Boeing 727 and 737. (CAM.)

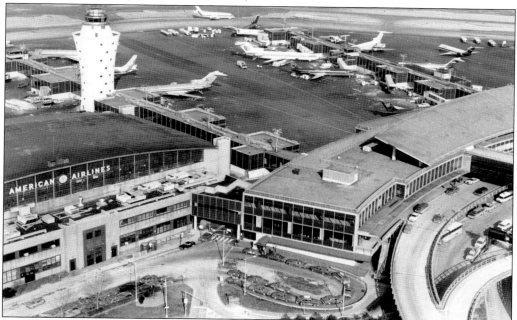

CENTRAL TERMINAL AND CONTROL TOWER, C. 1985. Because of American Airlines central role in the development of the airport, Mayor Fiorello LaGuardia gave the airline extra real estate, including four of the huge new hangars. They continue to use much of this space to this day. In the rear is a mix of DC-9s, 727s, and 737s. (PANYNJ.)

PILGRIM AIRLINES DEHAVILLAND TWIN OTTER, C. 1982. Much of LaGuardia Airport's traffic is now generated by regional and commuter airlines feeding into New York. Pilgrim Airlines (1962–1985), based in New London, Connecticut, was the first American operator of the Twin Otter. Designed as a bush plane, it found great success as a commuter. (PANYNJ.)

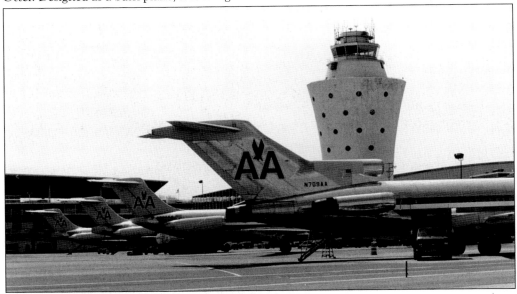

AMERICAN AIRLINES FIELDSIDE OPERATIONS, 1994. LaGuardia Airport continues to be a focus airport for American Airlines; it occupies all of Concourse D of the Central Terminal. In the foreground is a Boeing 727 with McDonnell Douglas MD-80s in the rear. The MD-80 series was derived from the DC-9 and was stretched to hold up to 161 passengers. The MD-80 was first delivered in 1980 and is no longer in production, although it remains in widespread use. (PANYNJ.)

DELTA AIR LINES BOEING 737 ON THE TAXIWAY, C. 1995. Designed as a replacement for the 727, the 737 has gone through nine variants and is now in the 900 series. This is a 400 series 737 capable of holding up to 170 passengers and cruising at 485 miles per hour. LaGuardia Airport remains an important destination for Delta; they left the Central Terminal for their own in 1983. (PANYNJ.)

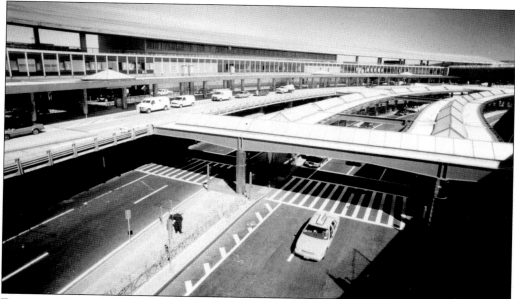

EXPANDED DEPARTURE-LEVEL ROADWAY AT THE CENTRAL TERMINAL, C. 1995. As part of the overall airport redevelopment and modernization program begun in 1987, substantial changes were made to the Central Terminal in the 1980s and 1990s. The expanded 56,000-square-foot arrivals area provided a much-enlarged common circulation corridor and exclusive baggage claim space for each airline. This photograph looks down on what was formerly Fiorello Park. (PANYNJ.)

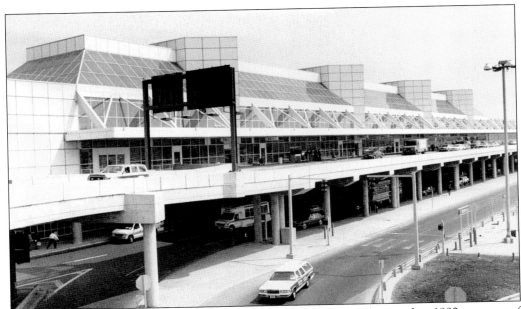

THE US AIR TERMINAL, 1994. This 300,000-square-foot terminal opened in 1992 at a cost of $250 million. The original tenant was intended to be the now-defunct Eastern Air Lines. The Trump Shuttle later occupied the terminal before selling the gate leases to US Air (now US Airways). According to the Port Authority of New York and New Jersey, this terminal handles about 50 percent of regional airliner traffic at the airport. (PANYNJ.)

INTERIOR OF THE US AIR TERMINAL, 1994. This new terminal was a major component of LaGuardia Airport's redevelopment and modernization program. The 12-gate terminal now serves US Airways, US Airways Express, and the US Airways Shuttle. (PANYNJ.)

THE DELTA AIR LINES TERMINAL, 2008. LaGuardia Airport's Delta Flight Center opened in 1983 at a cost of $90 million. It was designed to accommodate Delta's new Boeing 757 and 767 aircraft. Located at the eastern end of the airport, the terminal has 10 aircraft gate positions. Delta, operating the Boeing 767, is the only airline with wide-body flights to LaGuardia. (Tyler Stoff.)

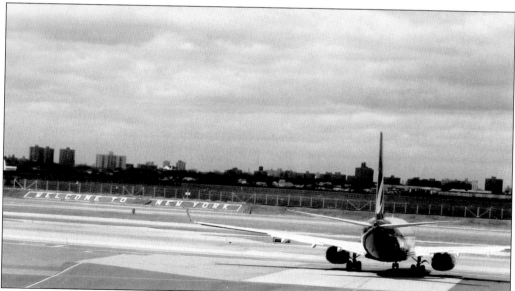

BOEING 737 ON THE TAXIWAY, 2008. This is a recent Boeing 737-800 series with upswept wingtips to reduce drag and seating for up to 189 passengers. In the rear is the iconic "Welcome to New York" sign with the apple alongside runway 31. Also visible in the distance is Flushing Bay, where flying boats once landed. (Tyler Stoff.)

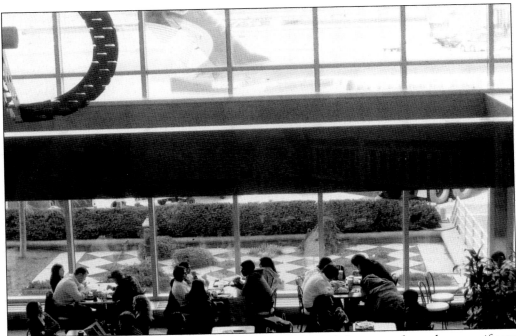

THE FOOD COURT OF THE CENTRAL TERMINAL, 2008. A long way from the magnificent Aviation Terrace Restaurant of 1939, at least some aviation action can still be seen from the dining area. The food court, including many new retail shops, was part of the mid-1990s redevelopment of the Central Terminal. (Tyler Stoff.)

HANGAR ONE AT LaGUARDIA AIRPORT, 2008. When these huge hangars were constructed in 1939, they were the largest aircraft hangars in the world. American Airlines, the original tenant, still operates them, although they are now largely used for airfreight rather than the original purpose, maintenance. The American Airlines logo with the eagle over the doorway is original and dates to 1939. (Tyler Stoff.)

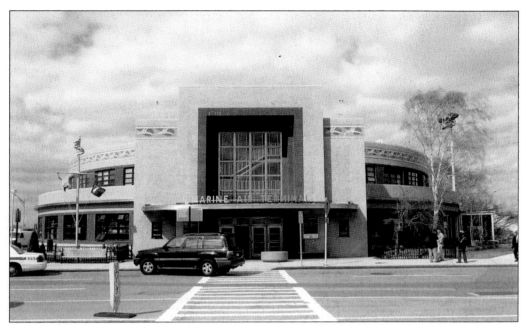

THE MARINE AIR TERMINAL, 2008. Still retaining much of its former glory, the Marine Air Terminal is still an active gate area 70 years after it was built. The exterior, including the famous flying fish frieze, appears virtually unchanged. Today the terminal houses the Delta Connection and Delta Shuttle, mainly serving Chicago, Washington, D.C., and Boston. (Tyler Stoff.)

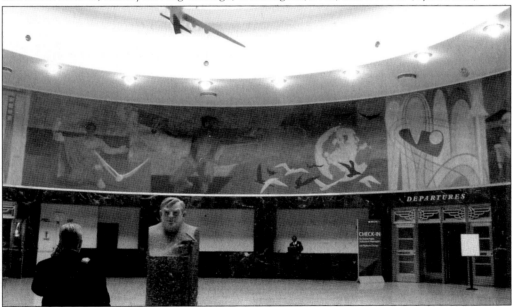

INTERIOR OF THE MARINE AIR TERMINAL, 2008. Based on the Roman Pantheon, the marble Marine Air Terminal structure appears unchanged from the day it opened. The magnificent James Brooks mural, thanks to Geoffrey Arend, has been masterfully restored. The central ticket counter, seating area, and huge globe no longer exist. They have been replaced by a large model of the Boeing B-314 and a stern-faced sculpture of Fiorello LaGuardia. (Tyler Stoff.)

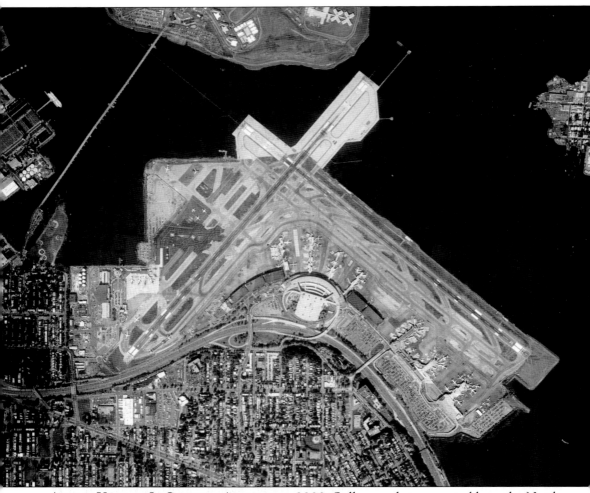

AERIAL VIEW OF LAGUARDIA AIRPORT, C. 2000. Still somewhat recognizable as the North Beach peninsula, the airport retains the basic plan laid out for it in the 1930s. In the center is the 1970s parking garage and the 1960s Central Terminal. The original 1939 hangars fan off to the sides and the Marine Air Terminal sits at the foot of Bowery Bay to the left. The airport is set off by the 1930s Grand Central Parkway, and Rikers Island, from where the landfill came, is at the top of the photograph. (PANYNJ.)

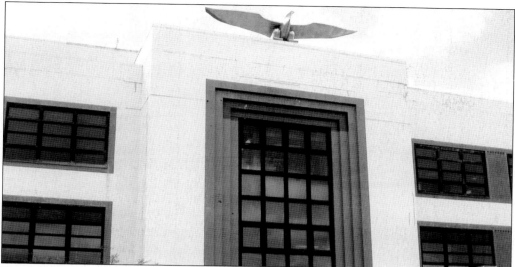

HANGAR SEVEN, SEAPLANE MAINTENANCE HANGAR, 2008. Today both the old and the new coexist at LaGuardia Airport. Hangar Seven, originally called the Seaplane Maintenance Hangar, now houses the Port Authority of New York and New Jersey administration, as well as Flight Safety International, an important pilot training and proficiency organization. The majestic stainless steel eagle on top was saved from the original 1939 Landplane Terminal when it was demolished in 1963. (Tyler Stoff.)

RENDERING OF LaGUARDIA AIRPORT'S NEW CONTROL TOWER, 2008. With 395,198 aircraft movements in 2007 and handling 25.4 million passengers, LaGuardia Airport remains one of America's busiest airports. No doubt as long as it continues to exist as an airport it will remain on a never-ending cycle of upgrades and redevelopment. Currently under construction and planned to open in 2009, is the airport's new control tower, seen here, the third in its existence. (PANYNJ.)

ACROSS AMERICA, PEOPLE ARE DISCOVERING SOMETHING WONDERFUL. *THEIR HERITAGE.*

Arcadia Publishing is the leading local history publisher in the United States. With more than 3,000 titles in print and hundreds of new titles released every year, Arcadia has extensive specialized experience chronicling the history of communities and celebrating America's hidden stories, bringing to life the people, places, and events from the past. To discover the history of other communities across the nation, please visit:

www.arcadiapublishing.com

Customized search tools allow you to find regional history books about the town where you grew up, the cities where your friends and family live, the town where your parents met, or even that retirement spot you've been dreaming about.